Ed. Manet

THE LIFE AND WORKS OF

Ed. Manet

MANET

Nathaniel Harris

A Compilation of Works from the
BRIDGEMAN ART LIBRARY

PARRAGON

Manet

This edition first published in Great Britain in 1994
by Parragon Book Service Limited

© 1994 Parragon Book Service Limited

ISBN 1 85813 585 0

Printed in Italy

Designer: Robert Mathias

Edouard Manet 1832-1883

Edouard Manet was one of the leaders of the 19th-century revolution in art, ridiculed and abused for most of his career as an arch-rebel. In a period of slick 'chocolate-box' art, full of false heroics and sugary sentiments, Manet was the supreme 'painter of modern life', devoted to portraying Parisian fashions and manners. But his pictures are works of art, not documentaries. His compositions are often witty variations on traditional designs, but he rejected the literal, 'photographic' style of his contemporaries and created an art of bold colours and contrasts, with cursorily painted passages that contemporaries regarded as skimpy but which we now see as exciting and energizing. Spontaneous and artful, ultra-modern and traditional, Manet's art bewildered his own generation, but has been a source of delight to the 20th century.

Manet was born in Paris on 23 January 1832. His background was upper-middle-class (his father was a senior civil servant) and, by contrast with many of his bohemian friends, Manet was always a polished gentleman and something of a dandy, very much at ease in good society. He was distressed and sometimes discouraged by the hostility shown towards his work, and always hoped for popular and official recognition – though he was evidently tougher than is sometimes supposed, since he refused to modify his style for the sake of success.

Manet was allowed to become a painter after a double failure, at school and as a naval cadet. He studied dutifully under a well-known master, and in 1861 had one of his paintings, *The Spanish Singer,* accepted by the jury of the official Salon. Since the Salon was virtually the only place where an artist could hope to have his work seen by large numbers of people, this was a first step in what might have become a conventionally successful career.

But Manet's conventional prospects were soon put in doubt when he started painting 'modern' pictures like *Music in the Tuileries* (page 10). None of his submissions to the 1863 Salon were accepted, but there were so many dissatisfied artists that the Emperor Napoleon III permitted an exhibition of rejects, the Salon des Refusés, to run concurrently with the official Salon. Manet's *Déjeuner sur l'Herbe* (page 13) caused a scandal at the Refusés, and worse was to come when his *Olympia* (page 15) was shown at the Salon two years later. Manet's chief offence was to exhibit naked, obviously modern young women; his respected contemporaries actually painted far more erotic nudes, but in safely 'classical' settings that made them less 'vulgar' and disturbing.

In the 1860s Manet became recognized as the leader of the younger generation, and fellow-rebels such as Edgar Degas and Claude Monet often gathered round him at the Café Guerbois and other haunts. But in 1874, when they organized a group exhibition – later known as the first Impressionist Exhibition – Manet remained aloof, continuing to believe that 'the Salon is the real field of battle'. However, contact with Monet did encourage him to experiment with painting out of doors and, more consistently, to use brighter colours.

In 1878 Manet began to suffer from pains in the legs,

the symptoms of the nervous disease locomotor ataxia; the cause was certainly an early infection of syphilis, a scourge that was the 19th-century counterpart of AIDS. Manet worked with increasing difficulty, producing a last masterpiece, *A Bar at the Folies-Bergère* (page 74), and continuing to paint flower-pieces almost to the end. On 14 April 1883 his left leg became gangrenous and had to be amputated, but the operation failed to save him. He died 16 days later, still only 51 years old.

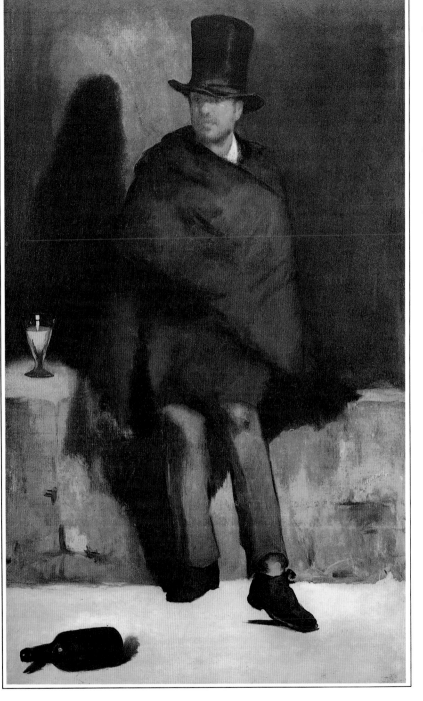

◁ **The Absinthe Drinker** 1858-9

Oil on canvas

THIS WAS MANET'S first bid for success, submitted in 1859 to the Paris Salon, which exhibited the best new works by French artists. He had taken his model from life, an alcoholic rag-picker named Collardet who hung around the Louvre. The Salon jury rejected *The Absinthe Drinker* as an unpleasant example of the realistic trends that were appearing; Manet's teacher, Thomas Couture, also denounced him. The brain-rotting qualities of absinthe were already well known, and Manet's picture might easily have been accepted as a moral lesson if the treatment of the subject had been more conventional. The drinker's blurred features are appropriate enough to the modern eye but the freedom with which Manet painted seemed merely incompetent to critics used to meticulously executed details. The drinker appears again, as one of a group, in Manet's painting *The Old Musician* (c.1862).

▷ **Lola de Valence** 1862

Oil on canvas

ALL THINGS SPANISH seemed exotic and romantic to the French for much of the 19th century. Manet shared this feeling, and also tried to exploit it: after the failure of *The Absinthe Drinker* (page 8), he had painted a rather hackneyed study of a guitarist, *The Spanish Singer,* which had been his first Salon success. The colourful *Lola de Valence,* a much better picture, was rejected for the 1862 Salon, but Manet remained interested in Spain (see pages 22 and 24). Lola Melea, known as Lola de Valence, was the star of the Camprubi dance troupe, which appeared at the Hippodrome and made enough of an impression for Manet's friend Zacharie Astruc to compose and publish a song about her; Manet made a lithographic portrait of her for the cover. This painting was done in the studio, but Manet added stage 'flats' and a glimpse of the audience waiting for Lola to come on.

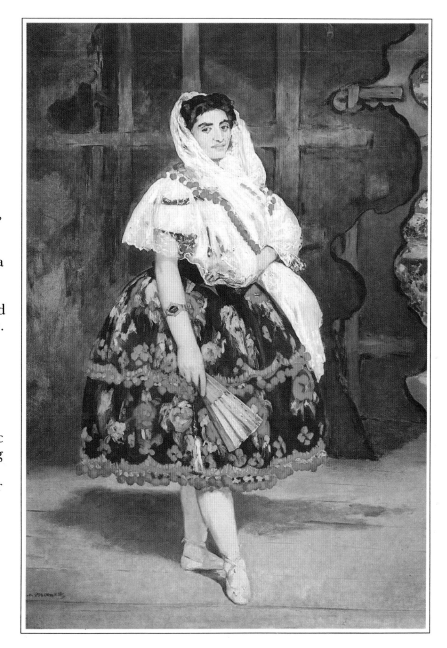

▷ **Music in the Tuileries** 1862

Oil on canvas

IN THE SPRING of 1863 Manet exhibited several paintings at the gallery run by his dealer, Louis Martentot. They were received without much enthusiasm, and *Music in the Tuileries* was positively abused because its subject was 'trivial'. This work is Manet's first indisputable masterpiece, and the first indication that he would become 'the painter of modern life'. The scene is the gardens close to the now-vanished Tuileries palace in Paris, where a band is playing to a fashionable crowd. Most of its members can be identified as prominent figures in artistic and literary life, including Manet himself (extreme left) and the poet Baudelaire, who had probably had a strong influence on the artist through his call for a painter who could grasp the heroic potential of men who wore neckties and boots. The painting has no single focal point, so that the eye moves restlessly across the canvas, as agitated as the crowd itself.

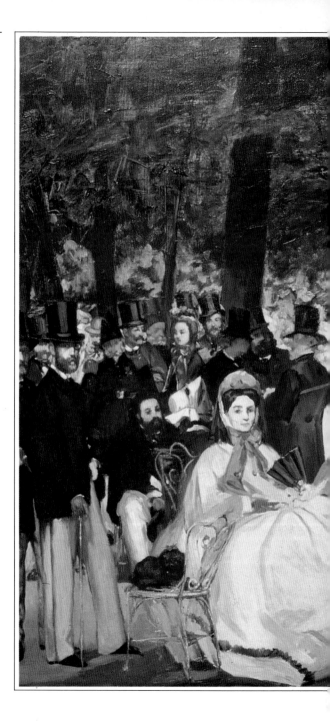

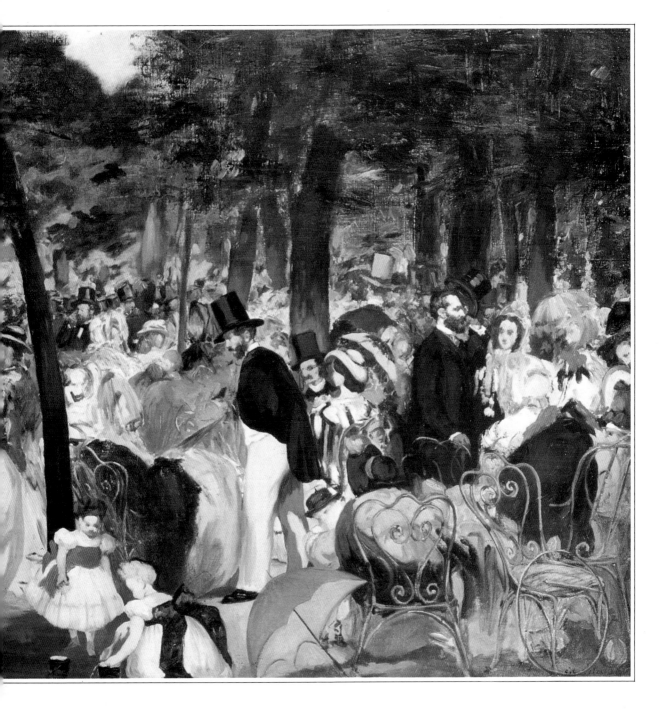

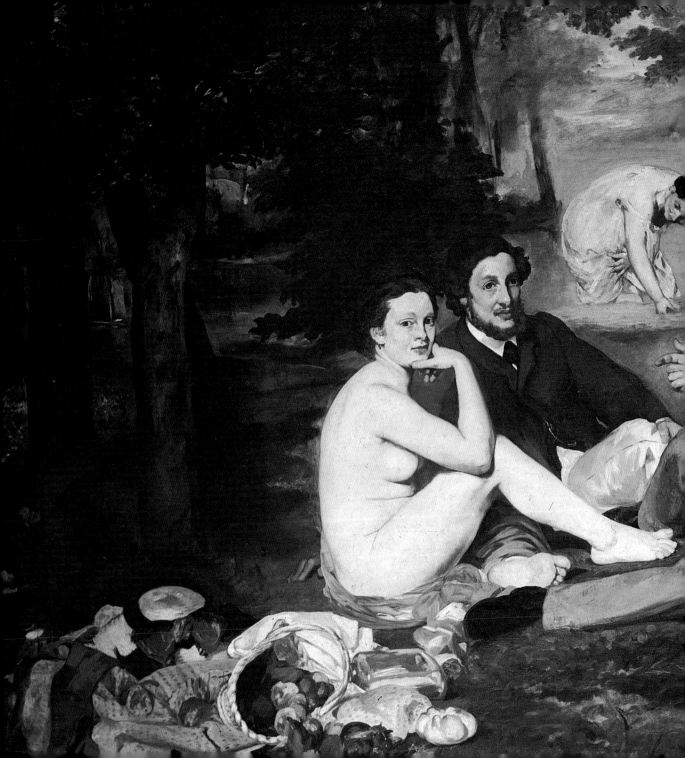

◁ **Déjeuner sur l'Herbe** 1863

Oil on canvas

ALSO KNOWN AS *Luncheon on the Grass* and *The Picnic*, this was the first of Manet's pictures to create a major scandal. It was one of the painter's boldest experiments in reconciling tradition and modernity, since the nude-clothed combination and country setting challenged comparison with the famous *Concert Champêtre* of the Renaissance master Giorgione, and even the grouping of the figures was based on a 16th-century engraving. But these 'respectable' antecedents were not enough to save the painting from a storm of abuse when it was shown at the 1863 Salon des Refusés. Much more erotic nudes were acceptable in the 19th century, provided they were vaguely 'classical' and remote; but a naked girl, cheekily looking straight at the spectator and accompanied by young men in modern clothing, was simply immoral! The model for the girl was Victorine Meurent, whom Manet painted many times; the men were probably his brother Gustave and the sculptor Ferdinand Leenhoff, who was soon to become his brother-in-law.

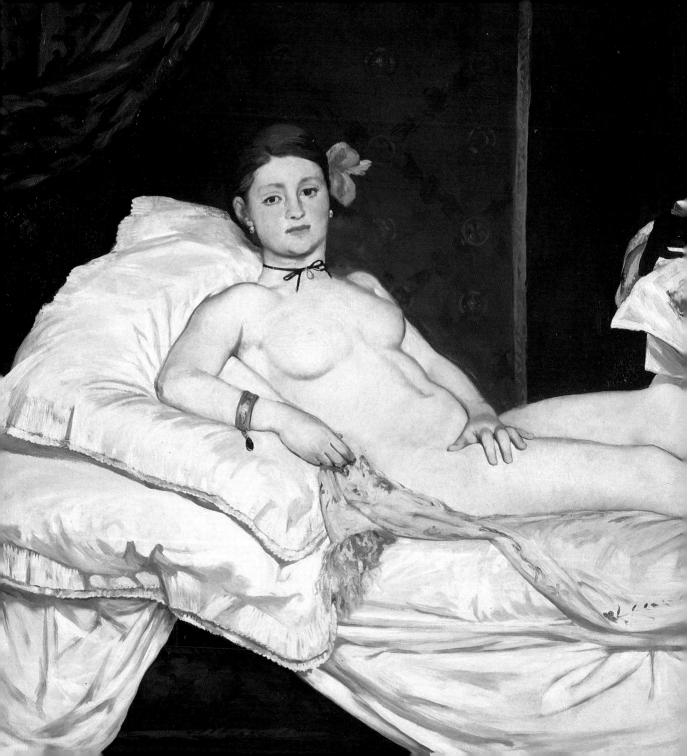

◁ **Olympia** 1863

Oil on canvas

IN *Olympia*, as in *Déjeuner sur l'Herbe* (page 13), Manet took a famous Old Master painting (in this case Titian's *Venus of Urbino*) and created his own 'modern' variation on it. Surprisingly, the jury accepted it for exhibition at the Salon of 1865, where it created the predictable storm; two attendants were detailed to protect it from attack until it could be hung much higher on the wall. People found Olympia offensive for two reasons: she was clearly a courtesan and she was not languorous and inviting but cool and confident, ready to stare down her visitor, i.e. the spectator, whose entrance has caused the cat to arch its back in hostility. Erotic details such as the ribbon round Olympia's neck and her one dangling slipper compounded her offence, although critics focused on her 'dirty' flesh and 'monkey-like' appearance to justify their ire. The model was Victorine Meurent, who also appears on pages 13 and 42.

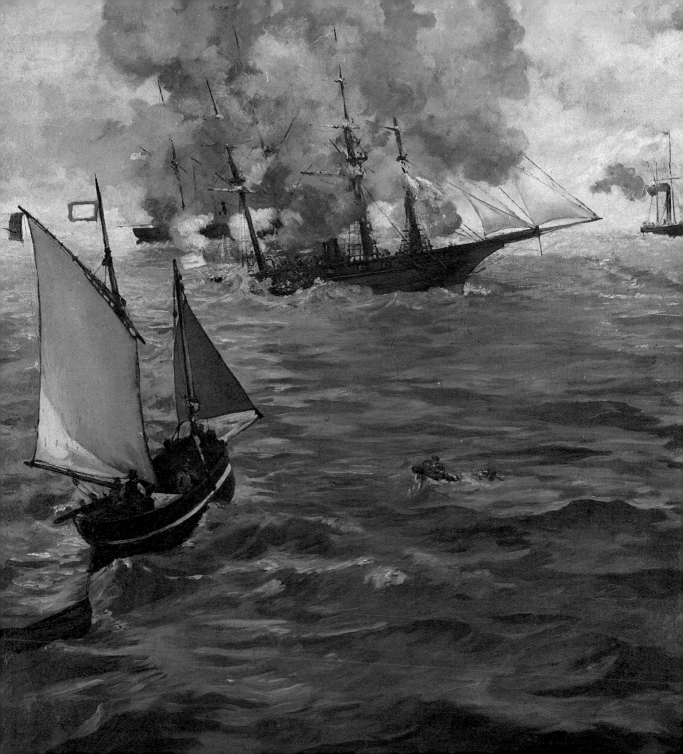

◁ **The Kearsarge and
the Alabama** 1864

Oil on canvas

THIS ENGAGEMENT at sea took
place during the American
Civil War between the
Northern (Union) and
Southern (Confederate) sides.
The Union corvette *Kearsarge*
finally caught up with the
Alabama, a highly successful
Confederate raider which had
been preying on Northern
shipping for two years, and the
duel between them was fought
out only a few miles from
Cherbourg. Crowds watched
from the shore, and according
to some accounts – probably
romanticized – Manet rowed
out to get a better look. What
is true is that his version of the
event is painted as if from a
vessel afloat, with a high
horizon and the heaving sea
filling most of the canvas.
The combatants are side by
side, bombarding each other
amid clouds of smoke. Manet
appears to have chosen the
moment when the *Alabama*
(closest to us) was smashed and
sank. This was the first picture
of Manet's to be inspired by
contemporary history.

**The Races at
Longchamp** c.1864

Oil on canvas

▷ *Overleaf pages 18-19*

THE SENSE OF MOVEMENT and
drama in *The Races at
Longchamp* is unusual in
Manet's work. Edgar Degas –
Manet's friend, but also his
sharp-tongued rival – boasted
that he was the first artist to
tackle the thoroughly modern
subject of racehorses and
jockeys; this is by way of being
Manet's response. Unlike
Degas, he paints the race itself,
and paints it as no one had
done before. Instead of being
shown from one side, the
horses are bearing straight
down upon us (a viewpoint
that would only become non-
suicidal when cameras could
be concealed on the course).
The cursory brushwork is
marvellously effective in
creating an effect of furious
action amid clouds of dust.
When this was painted,
Longchamp was only a few
years old; its position in the
Bois de Boulogne made it
Paris's own racecourse,
convenient even for an
inveterate townee such as
Manet.

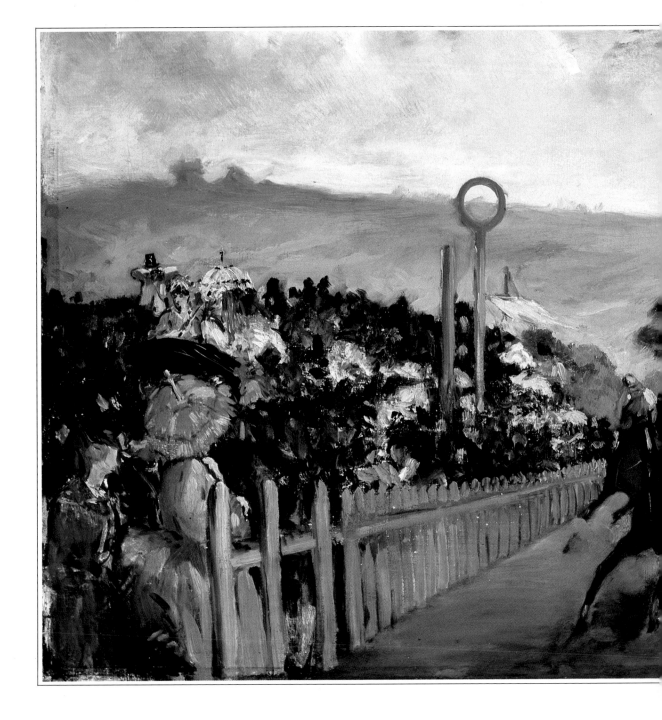

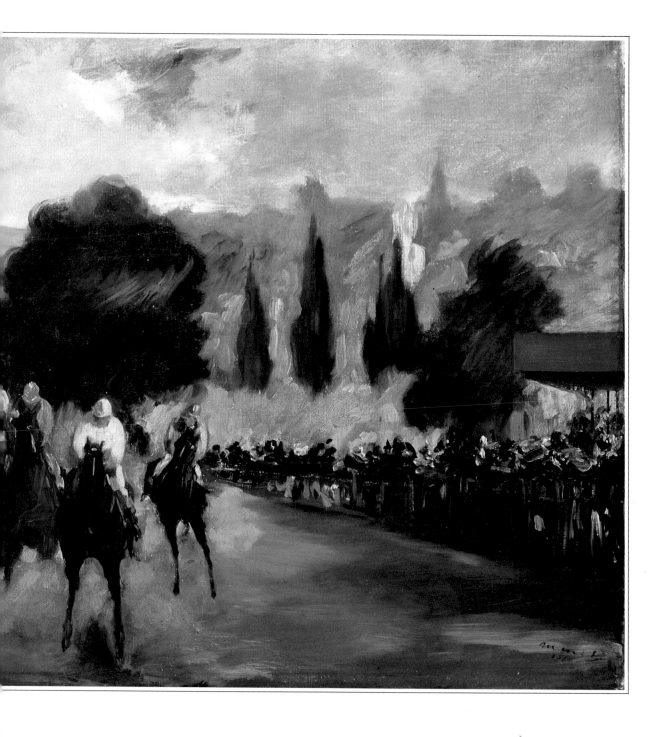

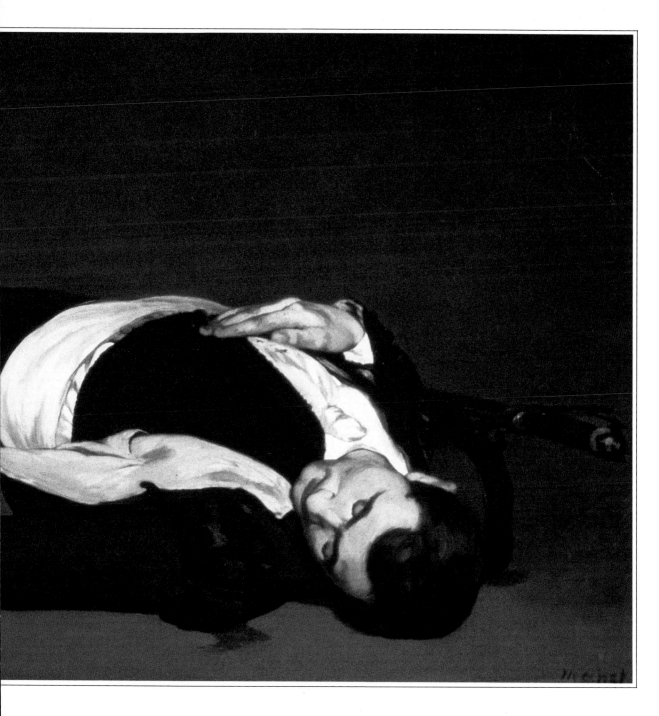

The Dead Toreador 1864

Oil on canvas

◁ *Preceding pages 20-21*

IN 1864 THE SALON jury accepted Manet's two submissions for that year. One of them was a large picture, *Episode from a Bullfight*, showing a dead matador and an angry bull still on the loose. Later on Manet cut up the painting, possibly stung by criticisms that the bull was too small; a newspaper cartoon even showed it as a child's pull-along toy, on wheels. One piece, *The Dead Toreador*, thus became a work in its own right, as did the other fragment, in the Frick Collection, New York. The picture is notable for its bold, beautiful colour scheme and masterly treatment of textures such as the dead man's stockings. It is another example of Manet's fascination with everything Spanish. Here he has attempted the most distinctively Spanish of all subjects – not too long before actually going to Spain for the first time.

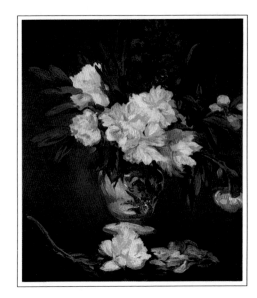

△ **Peonies in a Vase** 1864

Oil on canvas

PEONIES WERE introduced from the Far East into Europe during the 19th century. In Manet's day they still had an aura of exotic luxury, though the painter had no trouble in growing them on the family property at Gennevilliers. Manet occasionally turned to still life painting for relaxation, though flowers – specifically peonies – preoccupied him for only a short time until the final years of his life (see page 78). Both still life and flower paintings were well-known genres of the Dutch art that Manet admired so much, and so it is possible that the symbolic element in the Dutch works is echoed here: the unopened buds, full blooms and fallen, wilted blossoms comprise an entire cycle of growth and decay, reminding us of the fleeting nature of life. However, such reflections are not indispensable for the enjoyment of this sensuously pleasurable picture.

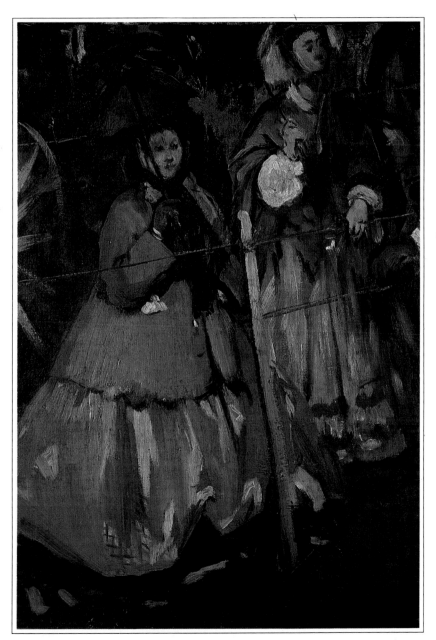

◁ **Women at the Races** 1865

Oil on canvas

MANET EASILY BECAME dissatisfied with his own efforts or discouraged by hostile criticism. When this happened he often destroyed ambitious works, but cut out parts which seemed good enough to stand by themselves as small paintings. *Women at the Races* is just such a picture, very broadly painted because the women were not originally the focus of the composition. Manet's observation is, however, acute: the woman on the right, her chin lifted so that she can see better, is caught in an attitude still visible on every racecourse. These are fashionable ladies, wearing smart bonnets and huge crinoline skirts beneath their outdoor clothing; the tiny parasol of the foreground figure is an intriguing touch. Manet's cutting has given this the appearance of a skilful composition, in which the glimpses of wheels are sufficient to indicate the presence of carriages behind the women.

▷ **The Bullfight** 1865-6

Oil on canvas

HAVING BEEN FOR YEARS influenced by the fashion for Spain, Manet finally crossed the Pyrennees and visited the country in September 1865, partly to escape the reverberating scandal over *Olympia* (page 15). Neither the food nor the climate agreed with him, and after ten days he was so homesick for Paris that he decided to return. However, he brought back with him the sketches he had made of bullfights visited with his friend Théodore Duret (page 29). Of the paintings he subsequently executed, this one is the largest and most finished. It captures the moment which Manet described in anticipation when he wrote to his friend Baudelaire of 'the picador and his horse overthrown and savaged by the bull's horns, while a cluster of chulos [assistants] attempts to draw off the enraged beast'. The faceless anonymity of the toreros and the crowd emphasizes the ritual quality of the bullfight.

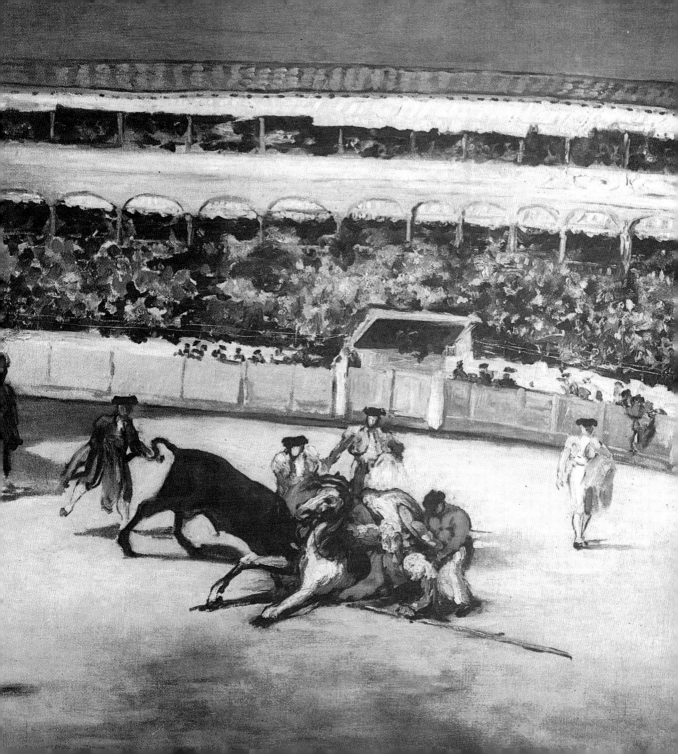

▷ **The Fifer** 1866

Oil on canvas

THE PROGRAMMED MENTALITY of 19th-century critics comes out particularly clearly in their reaction to this delightful picture: they hated it, and denounced it as 'an outfitter's signboard'. What offended them was Manet's decision to simplify the painting as far as was thinkable in the 1860s (later artists would go much further!). And so, although the fall of light on the folds of the uniform are recorded, most of the painting is in flat, bold colours, boldly outlined; a notably cunning touch is Manet's use of the black stripes on the boy's trousers as a heavy outline. In this painting, the two main influences on Manet came together: the strong outlines and colours owe much to Japanese prints, while the empty background (with just a hint of an aureole around the boy) is taken from Spanish portraits, especially those of Manet's admired master, Velazquez. The boy actually was a fifer, attached to the Imperial Guard.

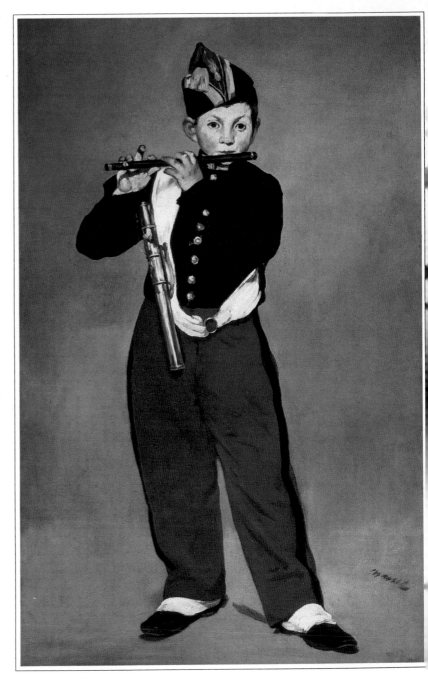

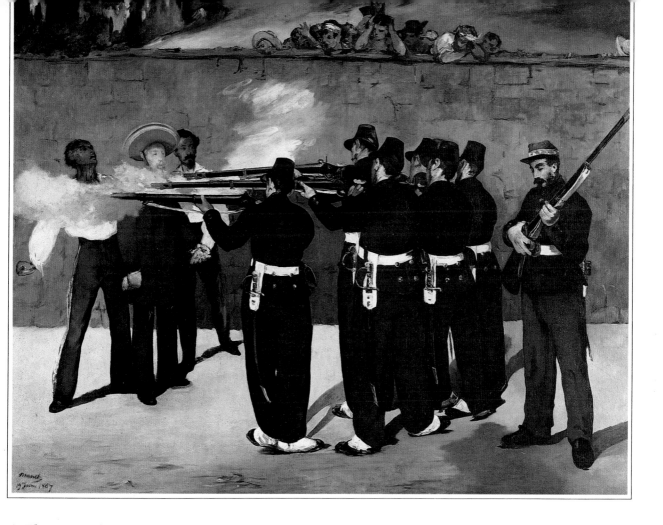

△ **The Execution of the Emperor Maximilian** 1867

Oil on canvas

MAXIMILIAN was an Austrian archduke placed on the throne of Mexico by Napoleon III. French troops kept him there until Napoleon withdrew them, bowing to pressure from the United States. Maximilian was captured by the Mexican resistance and executed along with two of his generals. The episode was seen as a humiliation for France, and Napoleon was widely blamed for it. As a republican, Manet was no friend to Napoleon's imperial regime. Public showings of Manet's *Execution* were forbidden and it was first seen in New York in 1879.

▷ **The Balcony** 1868

Oil on canvas

MANET WORKED very hard on this painting, and although not every part of it is successful, some passages of colour in it are superb, notably the lovely tinted whites of the women's dresses and the brilliant purple-blue of the necktie worn by the man with the cigarette. This is another painting which Manet executed as a variation on a Spanish theme. It challenges comparison with Goya's *Majas on a Balcony,* substituting 'modern' self-absorption for the intimacy of the original. The seated woman, elegantly arrayed in Spanish dress, is Manet's painter friend Berthe Morisot, whose portrait is reproduced on page 38. The man is the artist Antonin Guillemet, the woman pulling on her gloves Fanny Claus, a violinist. In the background, 16-year-old Léon Koëlla (see the captions to pages 30 and 34) carries a coffee service.

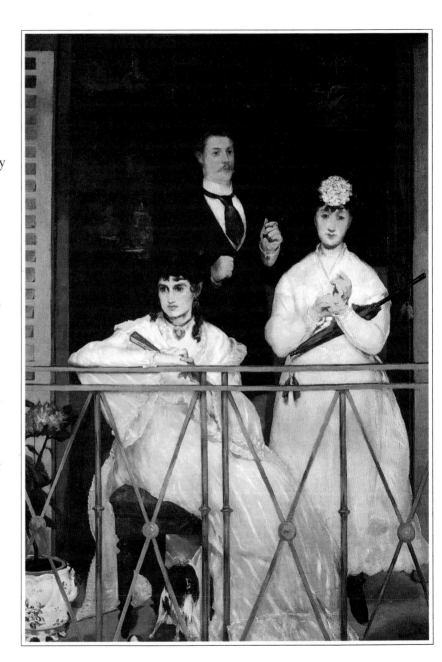

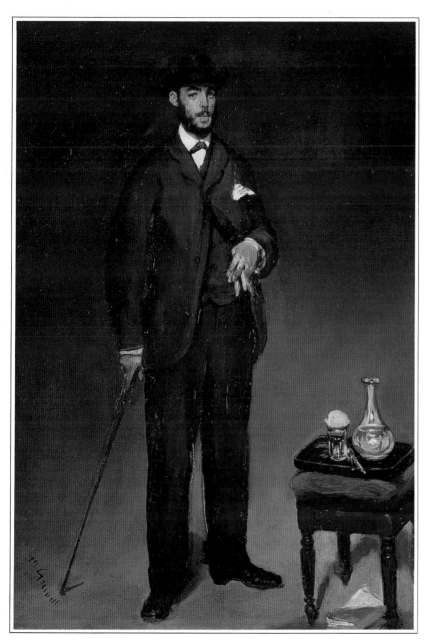

◁ Portrait of Théodore Duret 1868

Oil on canvas

DURET WAS A JOURNALIST and critic who met Manet in Spain during the artist's 1865 visit; together the two men went to bullfights, looked at the pictures by Velazquez in the Prado, and visited Toledo to see the cathedral and the paintings of another great Spanish (though Cretan-born) artist, El Greco. The portrait, apparently so straightforward, is highly effective. The figure of Duret, like *The Fifer* (page 26), is set against an unfilled background, but beside him are a fallen book, a stool, and a tray with a carafe and glass. Duret has left an entertaining description of the intuitive way in which Manet added one item after another, culminating in the all-important yellow of the lemon. A curious feature of the painting is Manet's upside-down signature, almost impaled like a worm on Duret's cane.

▷ **Luncheon in the Studio** 1868

Oil on canvas

ONE OF MANET'S most beautiful and harmonious paintings. It was mainly executed in Boulogne, where the Manets had rented an apartment for part of the summer, and where the artist also painted landscapes (see pages 33 and 37). There has been much speculation about the significance of the picture, but although it does suggest that some specific episode is being referred to, we do not know what it was. More generally, it could be a tribute to Dutch art, of which Manet was a great admirer: the scene has the cool beauty of a Dutch interior, while the food on the table and the armour and sabre on the chair could easily be isolated as examples of a great Dutch genre, the still life. Even the central figure is the Dutch-born son of Manet's Dutch wife, Léon Koëlla (probably Manet's son too; see the caption to page 34). The bearded man smoking a cigar is Auguste Rousselin, an artist whom Manet had known when they were both students; his function in the painting seems to be to introduce a coarse note that highlights the refined elegance of the young man.

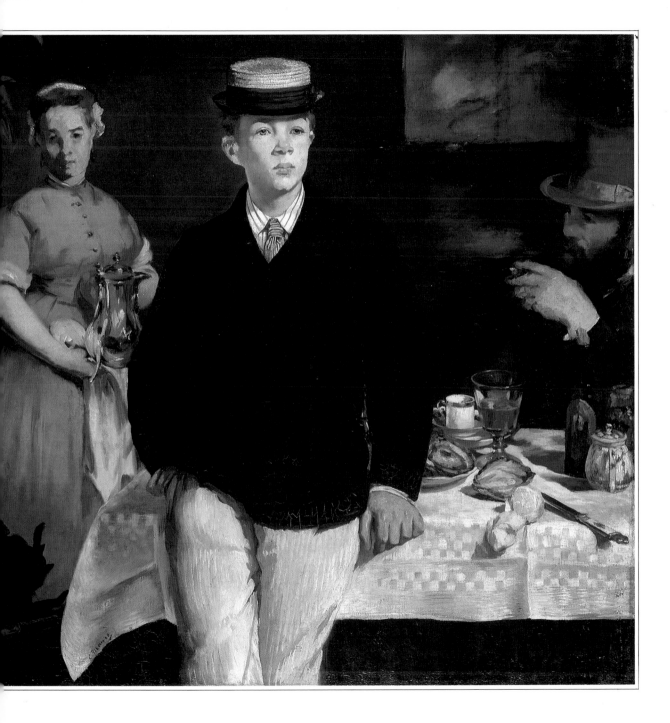

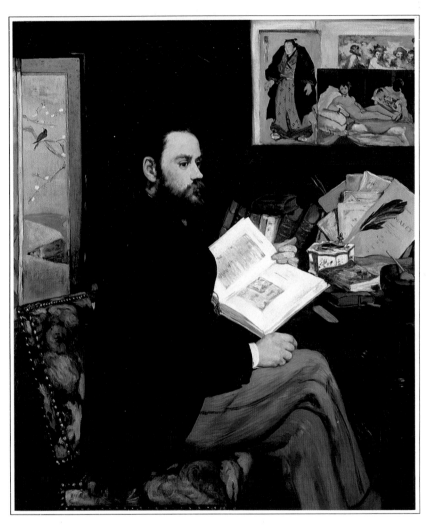

◁ **Portrait of Emile Zola** 1868

Oil on canvas

WHEN MANET PAINTED this portrait, Zola was not yet the author of exposé novels such as *Nana* and *Germinal.* He was a young journalist and art critic who had come down strongly on Manet's side in the many controversies surrounding his work. He had hailed pictures such as *The Fifer* (page 26), which had been refused by the official Salon jury, and in January 1867 he published the first serious study of Manet's work. Manet's response was to paint this superb portrait as a present for the writer. The likeness is a good but flattering one, though the objects in Zola's study say more about the painter than they do about his subject. The quill pen directs our attention to Zola's pamphlet about Manet, and three reproductions associate the artist with two main influences on his work: there is a Japanese print, a lithograph of a painting by the Spanish master Velazquez, and Manet's own *Olympia*.

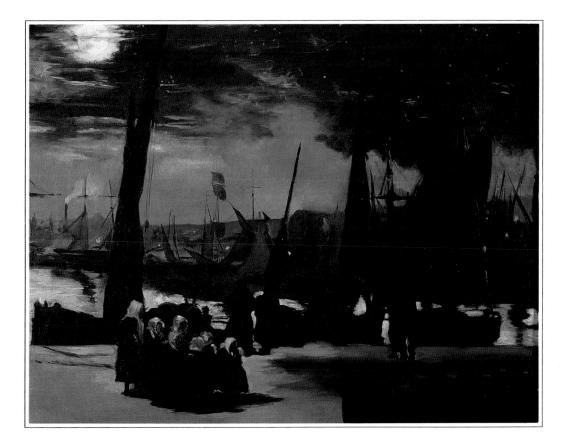

△ **Boulogne Harbour by Moonlight** 1869

Oil on canvas

IN 1869 MANET was still regarded as the leader of the rebellious younger generation, but new and challenging figures such as Claude Monet and Pierre Auguste Renoir were emerging. They were cronies of Manet's, often turning up at the Café Guerbois where he spent so many of his evenings. Consequently he was well aware of their conviction that painting *en plein air* (out of doors), directly in front of the subject, made for a spontaneity and freshness that formal academic landscapes could not achieve. Holidaying at Boulogne, Manet made his first experiments in this direction, producing the lively, bustling *Departure of the Folkestone Boat. Boulogne Harbour by Moonlight* is a kind of companion piece: the quay is still as the womenfolk huddle together, waiting for the return of the fishermen, and the masts are at rest, pointing at the brilliantly starry night sky.

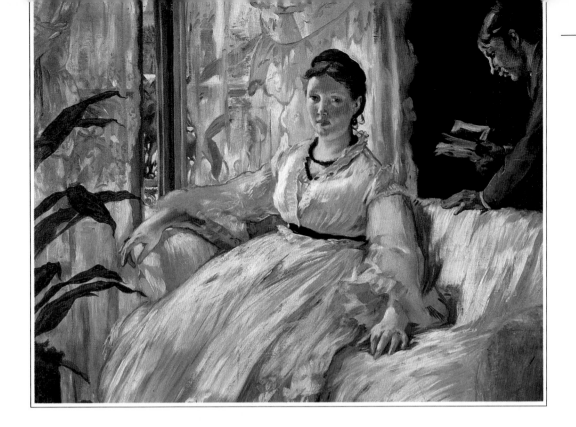

△ **Reading** 1869

Oil on canvas

THIS IS A *tour de force* of white-on-white, with passages of wonderful painting which convey the gauzy semi-transparent quality of some of the materials. The sea of whiteness serves to emphasize the full, healthy flesh tones of the woman's face, to remarkably flattering effect. She is Manet's wife Suzanne, a Dutch girl who as Suzanne Leenhoff had worked as a piano tutor in the household of Manet's parents. Two years older than Manet, she had gone back to the Netherlands to bear a child, known as Léon Koëlla or Léon Leenhoff, who was often passed off as Suzanne's younger brother. The presumptive father, Koëlla, probably never existed. Manet's patent affection for the boy, the number of times he painted him and the terms of his will make it virtually certain that he was Léon's father. However, Manet did not marry Suzanne until 1863, a fact that may not be unconnected with his father's death the year before.

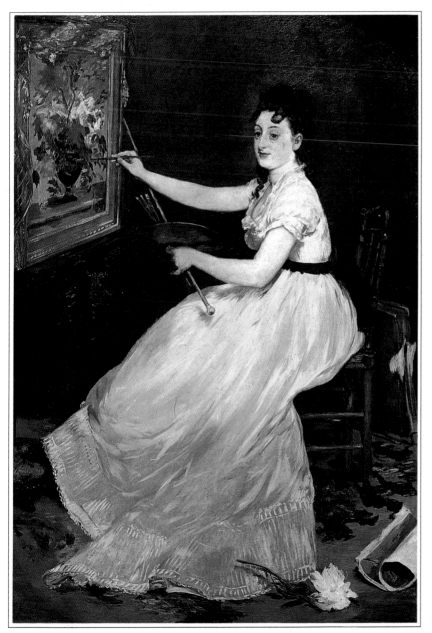

◁ **Portrait of Eva Gonzalès** 1870

Oil on canvas

EVA GONZALES was the only person whom Manet accepted as a pupil on a formal basis, although he certainly influenced his painter friend Berthe Morisot, who became a little jealous of Gonzalès. Manet's pupil was the 20-year-old daughter of a novelist, and had already studied under a fashionable but now forgotten artist named Chaplin. She seems to have learned more from Manet and, although she did not have a great talent, enjoyed a pleasant degree of success, less qualified than anything known by the master himself. Manet began the portrait almost as soon as Gonzalès joined him. Although it shows her at work, it seems designed to emphasize her amateur status, since she is hardly dressed for the job and seems to be painting with a flourish from a distance rather than concentrating!

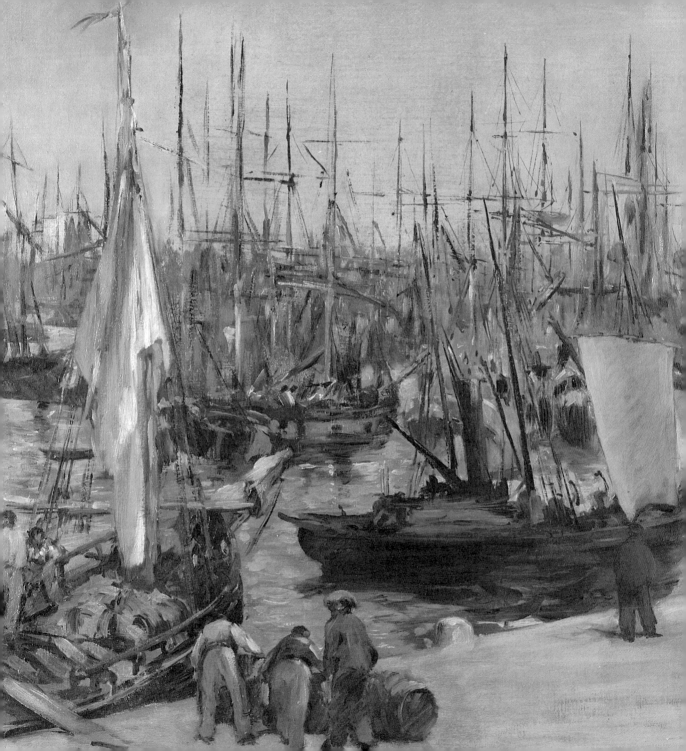

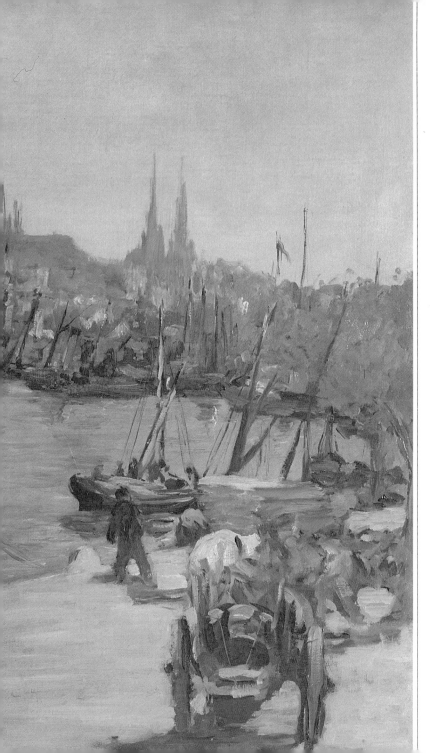

◁ The Harbour at Bordeaux 1871

Oil on canvas

ALTHOUGH ONE WOULD never guess it by comparing them, fearful months of war and suffering separate this painting from the previous one. In July 1870 the Emperor Napoleon III declared war on Prussia. French armies were defeated, and the Prussians besieged Paris. Manet evacuated his family but stayed on as an officer in the National Guard. During the four-month siege Paris starved, and Manet himself was 'dying with hunger'. The city capitulated on 28 January, and a fortnight later Manet joined his family in south-west France, spending several weeks on the coast at Arachon. While he was making the necessary arrangements at Bordeaux, he painted this picture from a café window. The scene is a tranquil one, in which the foreground activities make less of an impression than the fascinating pattern of masts and the cathedral spires.

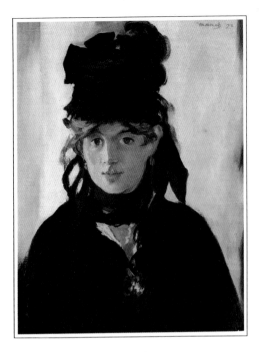

△ **Berthe Morisot** 1872

Oil on canvas

MANET MET BERTHE MORISOT in the late 1860s, and she became a close friend of his family. He used her as a model on several occasions, notably for *The Balcony* (page 28). Morisot was a painter of real talent, and although she learned from Manet she became a devotee of outdoor painting and a respected member of the Impressionist group, whose principles Manet never wholeheartedly subscribed to. One of Manet's trademarks was his skilful use of black (a colour abolished as 'unnatural' from the Impressionist palette), used to great effect in this portrait. But despite its strong presence here, it is Morisot's face that dominates the picture, her keen, direct gaze locking on to the spectator's and making it difficult to look at any other area. As far as is known, Morisot's relationship with Manet was purely platonic; in 1874 she married his brother Eugène.

▷ **The Railway** 1873

Oil on canvas

A PAINTING OF STRANGE contrasts: the exquisite colours, the attractive blue-clad woman with her lapdog and book, the prettily-dressed little girl watching – and the noisy, grimy background of locomotives and rolling stock. The setting is the railway line just outside the Gare St-Lazare, the great Parisian station not far from Manet's studio and his haunts in the Batignolles quarter. For all his interest in becoming the 'painter of modern life', Manet's relationship with the contemporary world was an oblique one, mediated through art; so it is appropriate that there are no locomotives on view here, only the great clouds of steam that signal their presence. The woman is Victorine Meurent, the model for *Déjeuner sur l'Herbe* (page 13) and *Olympia* (page 15).

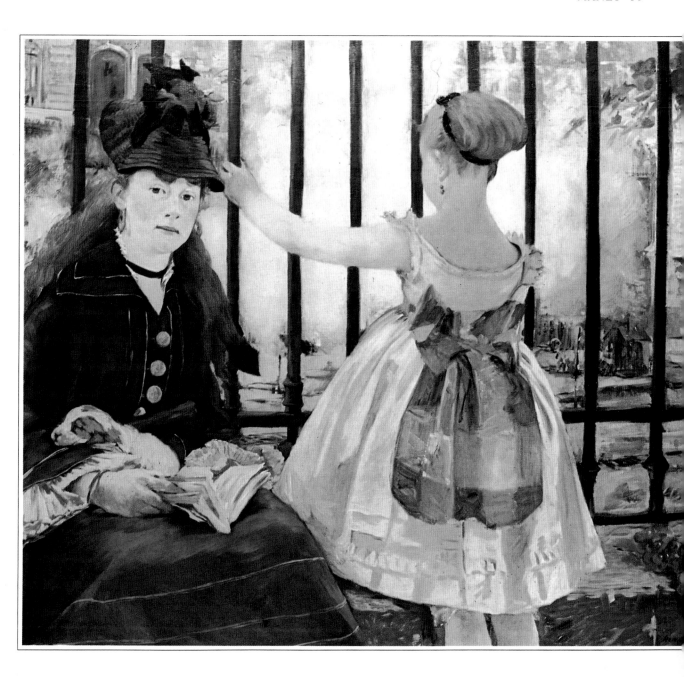

▷ **On the Beach** 1873

Oil on canvas

IN 1869 MANET had begun to interest himself in outdoor painting, prompted by the experiments of younger friends such as Claude Monet. During that year, Monet and Renoir had developed a new technique involving the rapid application of blobs of pure colour to build up a vivid, atmospheric picture of the scene they were painting. This became the technical basis of the Impressionist landscape, violently abused in its time but immensely popular with 20th-century gallery visitors. Manet never adopted the full Impressionist technique, but he was no stranger to the practice of painting some areas in cursory fashion, eliminating unnecessary detail and giving a sense of movement, and from 1873 he worked outdoors again on occasion. At Berck, not far from Boulogne, he painted a number of seascapes and, most successfully, this beach picture, for which his wife Suzanne and his brother Eugène were the models.

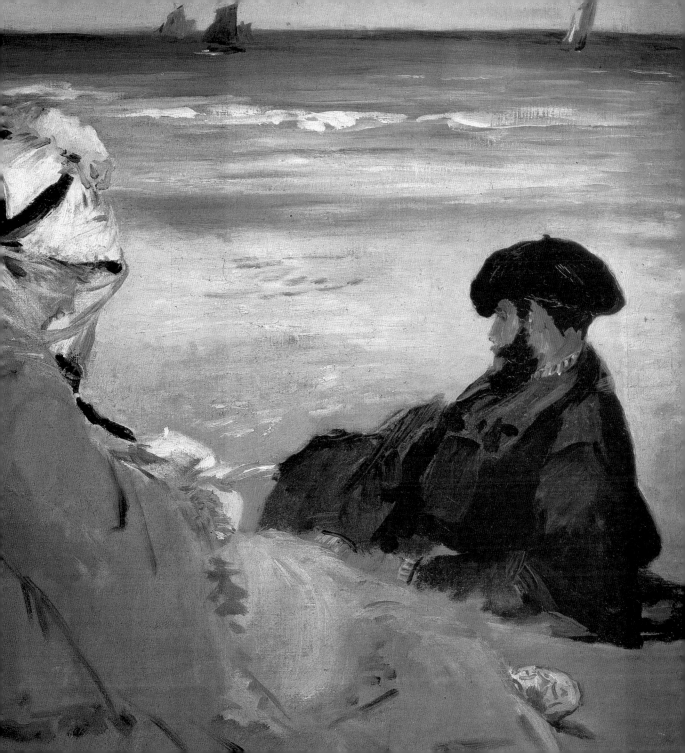

▷ **A Game of Croquet** 1873

Oil on canvas

THIS COOL, LEAFY SPOT is the
Paris garden of Alfred Stevens,
a fashionable Belgian painter
who was also a friend and
supporter of Manet; he may
well be the man with his back
to us. The women have been
identified as Victorine
Meurent, the model for some
of Manet's most celebrated
pictures (pages 13 and 15) and
Alice Lecouvé, Stevens's
model, who is about to strike
the ball. In the background,
another of Manet's friends,
Paul Roudier, seems more
interested in the beauties of
nature than in the game.
Stevens's garden was often the
scene of croquet matches, so
he must have been an
enthusiast. But here the
contest is between the women
and they seem to be taking it
with some seriousness; their
long, voluminous summer
wear explains why such a
stately game seemed to be
suitable for ladies. Manet's
pleasant, freely painted picture
was lost for years, until it
turned up in a junk shop.

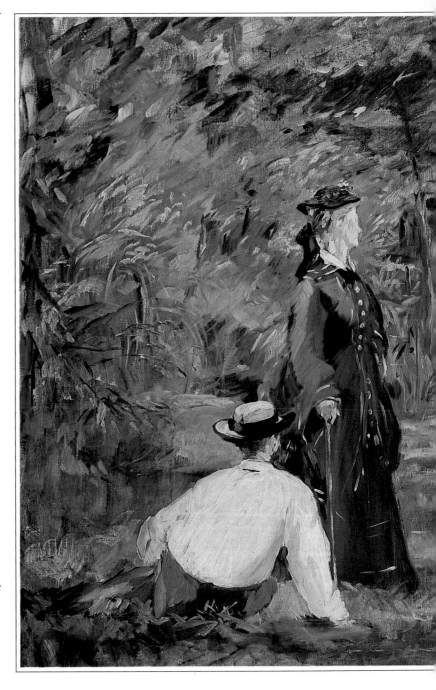

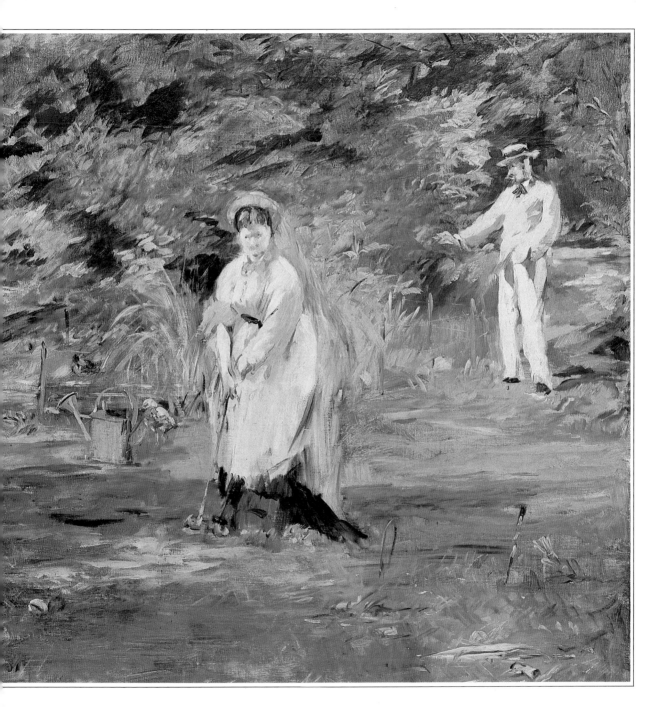

▷ The Lady with the Fans 1873-4

Oil on canvas

THE SITTER FOR THIS PORTRAIT was Marie Anne Gaillard, a Parisian character who preferred to be known, more exotically, as Nina de Callias. Her lifestyle was bohemian and self-destructive, but for some years her salon was an important meeting-place for artists and intellectuals; her generosity and real talents made her many friends, but she burned herself out and died at the early age of 39. Manet's painting manages to suggest her rather dubious position in society while not being in the least unfriendly. The background of fans adds to the effect, but it also reflects Manet's love of the Japanese art which so greatly influenced his own. Nina's costume is said to be Algerian, and although the painting was done in Manet's studio the setting was arranged to resemble that of her town house.

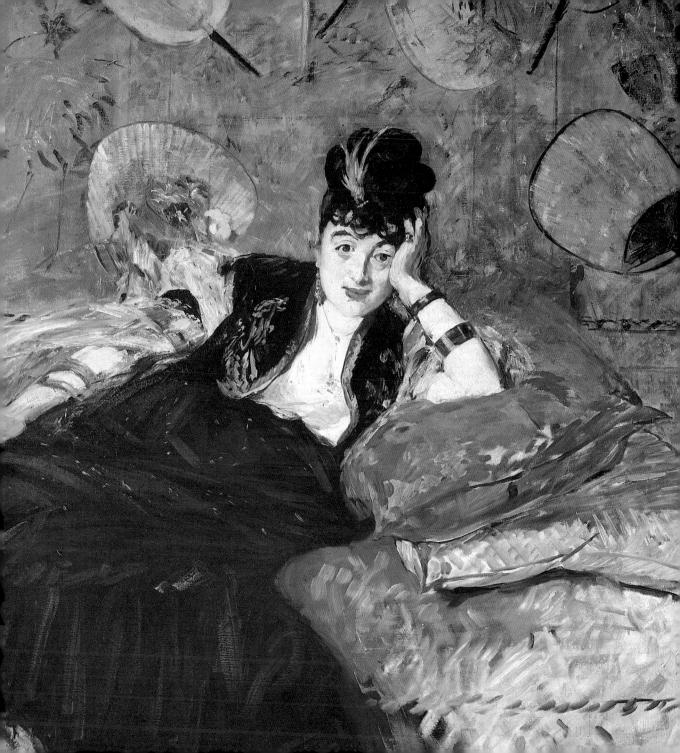

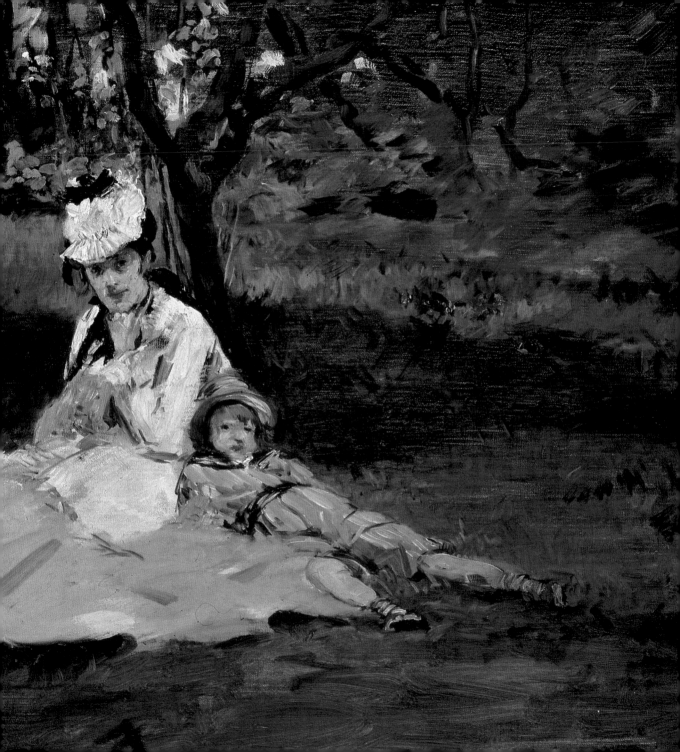

The Monet Family in the Garden 1874

Oil on canvas

◁ *Preceding pages 46-47*

MANET WAS WIDELY regarded as the leader of the rebellious younger generation, and artists such as Claude Monet and Pierre Auguste Renoir were sometimes known as *la bande à Manet* – 'Manet's following' or 'Manet's gang'. But although Manet knew several of them from café discussions, he did not share their preoccupation with open-air painting and refused to take part in the epoch-making first Impressionist Exhibition in April 1874. Nevertheless he admired the talent of Monet in particular, and the two men saw a great deal of each other in the summer of 1874. Here, Manet, the studio painter, has worked at speed outdoors to capture a delightful moment in Monet's garden. Madame Monet sits up against a tree, and her son Jean sprawls against her, while chickens run about and Monet does the work.

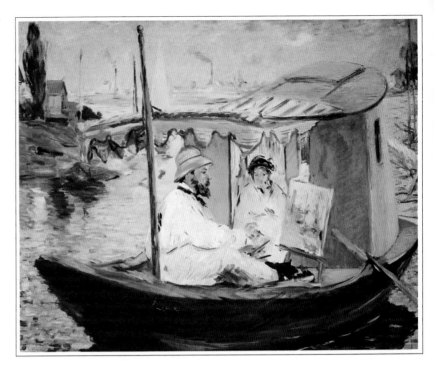

△ Monet Painting in his Studio Boat 1874

Oil on canvas

MANET SPENT THE SUMMER of 1874 at Gennevilliers, on the opposite side of the River Seine from Argenteuil, where Claude Monet lived. Manet and Monet spent a good deal of time together and often painted side by side. Thanks to Monet's influence, Manet painted more often in the open air and lightened his palette, although he remained characteristically more interested in figure subjects than in pure landscape. Here he has captured Monet and his wife Camille in the boat which the painter used as a floating studio, rowing it up and down the Seine and stopping whenever he spotted a promising subject. Monet was often desperately poor, but could always rely on a loan from Manet – who was equally unpopular but less dependent on art for his income.

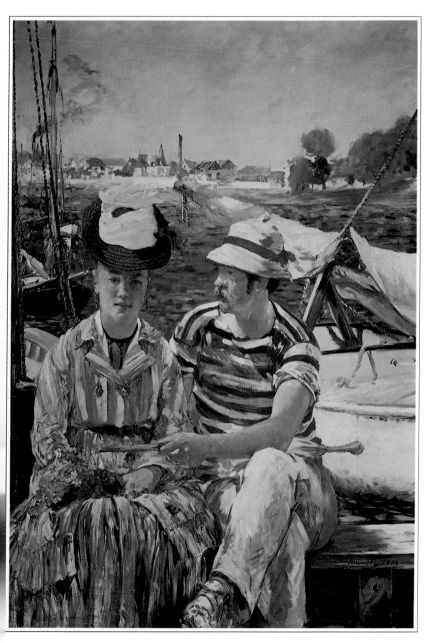

◁ **Argenteuil** 1874

Oil on canvas

ONE OF THE MOST brilliantly atmospheric of the pictures painted by Manet during the summer he spent by the Seine, staying at Gennevilliers. This little resort, unseen, is actually where the picture's central figures and boats are situated: Argenteuil lies across the brilliant strip of water, which, a literal-minded critic complained, was a 'madly blue Mediterranean' and therefore a falsehood. Manet intended to paint Claude Monet and his wife Camille as the holidaymakers, but when they failed to stay the course he brought in two new models. The identity of the woman is unknown, but the man is probably Manet's brother-in-law, the painter Rudolf Leenhoff, though one later witness claimed he was a certain Baron Barbier, a friend of the writer Guy de Maupassant – appropriately, since this painting and *Boating* (page 52) could easily be illustrations for Maupassant stories.

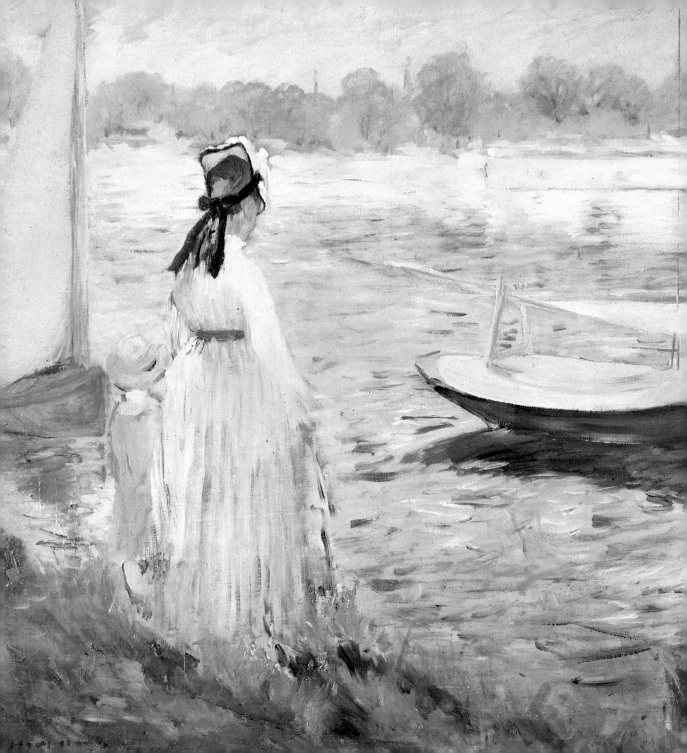

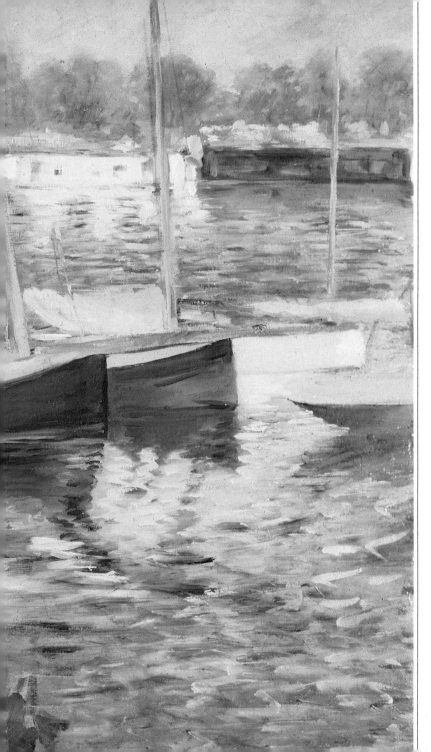

◁ **The River at Argenteuil** 1874

Oil on canvas

A PICTURE OF QUIET BEAUTY, perhaps as close as Manet ever came to evoking the pure pleasure in nature that is uppermost in Impressionist painting. Here the pleasure comes from the sense of peace created by the slow, regular movement of water and the gentle, repeated reflections. Even in this idyll the human presence is strong, though for once Manet has muted it by painting the figures turned away from us and absorbed in the scene. The models may have been Camille, the wife of Manet's painter friend Monet, and their son Jean. The view is painted from Gennevilliers, where Manet spent the summer of 1874, so that we are looking across the river at Argenteuil, which also appears on page 49. The horizontal white building on the Argenteuil bank was a bathing establishment.

▷ **Boating** 1874

Oil on canvas

THIS IS ANOTHER of the fine summery pictures painted by Manet while he was staying at Gennevilliers, in close contact with Monet and Renoir. The woman may well be Camille Monet (her hat certainly looks the same as the one in *The River at Argenteuil*, page 51); the man with his hand on the tiller resembles the male model for *Argenteuil* (page 49). But the picture is so carefully composed that it seems unlikely to have been painted outdoors in the Impressionist style. Objects close to the edges of the scene have been cut off, in a fashion that the more discerning French painters had learned from Japanese prints. The angle from which it is seen excludes the sky and horizon, enhancing the water-bound unity of the composition. The silky sheen of the woman's dress is a *tour de force* of feathery brushwork, in striking contrast with the technique used in other areas of the picture.

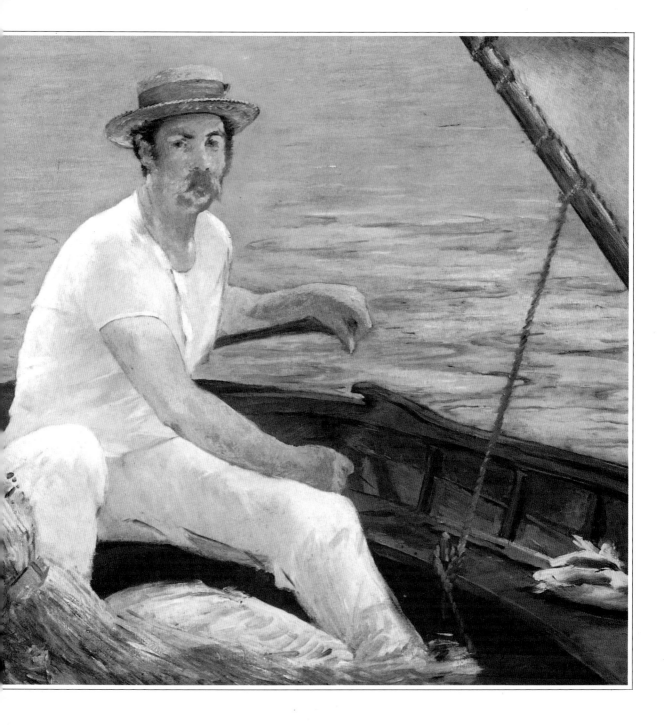

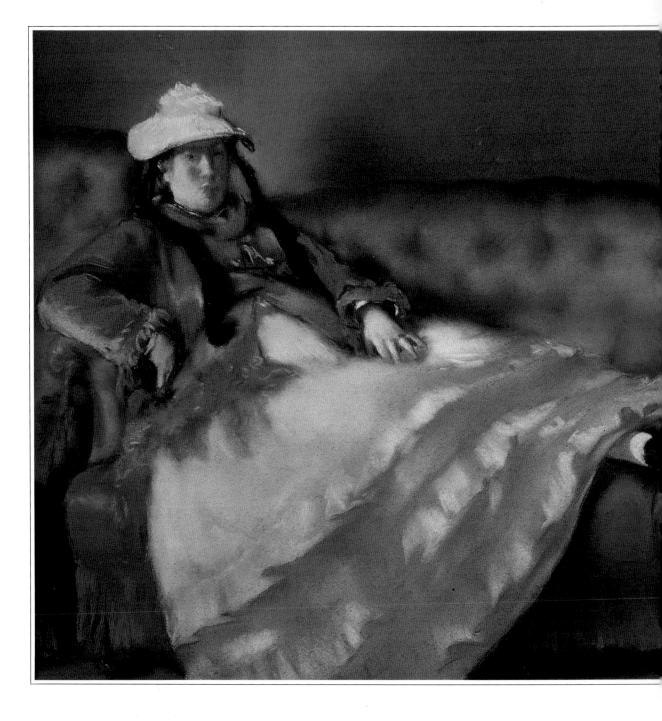

◁ **Madame Manet on the Sofa** 1874

Pastel on paper

MANET MADE A NUMBER of portraits of his wife, but this is the only one in pastels. Rich and soft, the medium lends itself to the creation of areas of glowing colour and lovely textures. The sweetness and intensity of Manet's work are oddly at variance with Madame Manet's attitude: perhaps it is simply a modern misreading, but she looks dumpy and cross, as if she has just come home, hot and bothered, from doing the shopping, and has collapsed disgruntled on the sofa! This is all the more curious since Manet was quite sensitive about his wife's appearance. When Edgar Degas, his friend and an equally distinguished artist, painted Madame Manet playing the piano while her husband lounged on the sofa, Manet was so put out by the way Degas showed her in profile that he cut off the offending right-hand section of the picture and destroyed it!

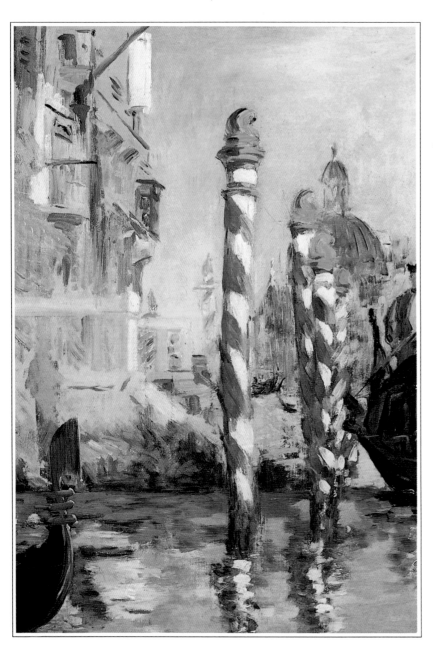

◁ **Grand Canal, Venice** 1875

Oil on canvas

MANET VISITED VENICE in September 1875 with his friend and fellow-painter James Tissot, who had settled in London after the Franco-Prussian war of 1870-1. Although the watery splendour of Venice has inspired many great artists, Manet found it hard to settle, and only two paintings survive to commemorate the trip: *Grand Canal, Venice* and a more straightforward canal-and-gondola scene, *Blue Venice*. The Grand Canal is Venice's 'main street', majestically broad and lined with elegant buildings rising straight up out of the water. However, Manet has avoided panoramic views of a kind that had been painted many times before, creating instead a fine composition in which the vertical lines of the buildings are background supports to the blue-and-white canal posts and the elegant prow of a gondola.

▷ **The Artist** 1875

Oil on canvas

ON ONE LEVEL this painting might be considered a joke of Manet's – against himself, or perhaps against his entire profession. The Artist looks bohemian and a little disreputable; and he actually was. This is a portrait of Marcellin Desboutin, an aristocratic artist and poet who never shook off a happy-go-lucky amateurism; he was a very different character from his fiery cousin, Henri Rochefort, whom Manet would paint a few years later (page 73). The dog drinking beer from the bottom of a glass is a masterly touch, strengthening the impression of an amiable but slovenly way of life. Desboutin was a member of Manet's set, frequenting the same cafés, the Guerbois and later the Nouvelle Athénes; Manet's view of his character is confirmed by his appearance a year later as the drinker in Degas's famous painting *Absinthe*.

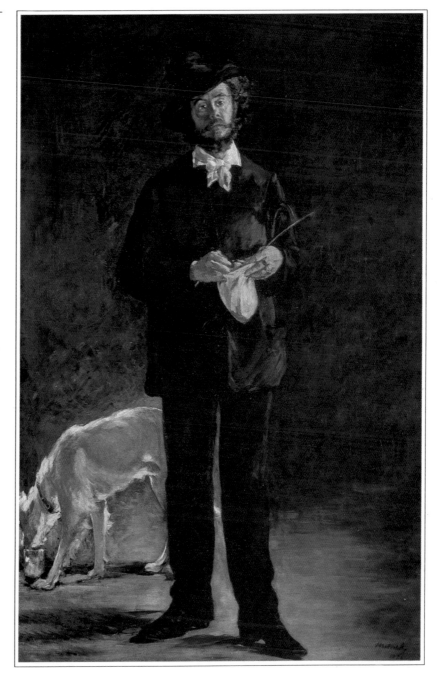

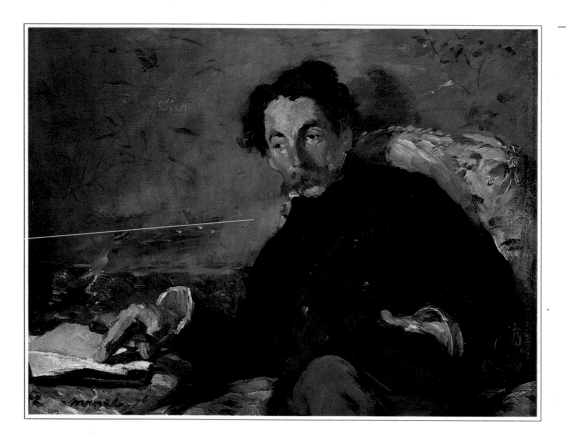

△ **Portrait of Stéphane Mallarmé** 1876

Oil on canvas

MANET WAS A CULTIVATED man whose friends included two of the greatest French poets of the 19th century, Charles Baudelaire and Stéphane Mallarmé. Baudelaire died in 1867, but Mallarmé, ten years younger than Manet, outlived the painter. The two men became friends in about 1873, when both were living in the Batignolles quarter of Paris. At the time, Mallarmé was an unknown teacher of English, but he soon made a reputation, although his difficult verse never became widely popular. He wrote important essays in defence of Manet, while the artist illustrated Mallarmé's *Prélude à l'après-midi d'un faune* and his translations of the American writer Edgar Allan Poe. Here Manet has shown his friend in a deliberately casual pose, lounging with one hand in his pocket while smoking a cigar; there is no reference to his literary gifts except, perhaps, for the book or manuscript on which his hand rests.

▷ **Faure as Hamlet** 1877

Oil on canvas

THE WELL-KNOWN SINGER Jean
Baptiste Faure is shown here
as Hamlet, in the opera by
Ambroise Thomas based on
Shakespeare's tragedy. This
was Faure's most celebrated
role: he had made his
reputation with it at the Paris
Opéra in 1861, and was now at
the end of his distinguished
career there. Manet portrays
him in his traditional black
costume, with drawn sword as
though about to take part in
the bloody climax of the
performance. But for the
moment he is alone, and the
absence of any stage properties
emphasizes the fact: this is the
soliloquy or, since the work is
an opera, the solo aria. Faure
was a friend and patron of
Manet's who had bought a
number of the painter's works
in the early 1870s. However,
when Manet came to paint his
portrait, Faure was not
satisfied and refused to accept
it. Manet may have felt that
Faure had a point, for he went
on to paint this, the second
and more forceful version.

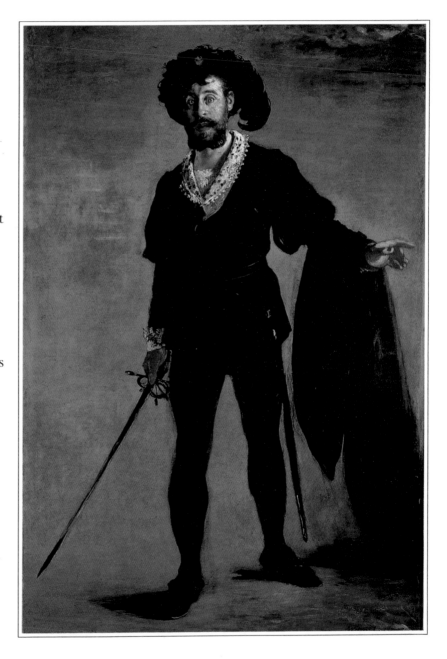

▷ **Nana** 1877

Oil on canvas

WITH *Nana*, MANET returned
to an 'unmentionable' subject
he had tackled in Olympia
(page 15); but in this picture
the mood is softer and less
challenging. Making herself
up with lipstick and powder
puff, Nana stands before the
mirror, perfectly self-
possessed, in her underwear.
She ignores her elderly
admirer, but pauses to direct
an amiable, complacent glance
at the spectator. The name
Nana was that of a character
who had appeared in Emile
Zola's novel *L'Assommoir*.
Moreover, Manet probably
knew that Zola, whom he had
painted years before (page 33),
was writing a novel in which
Nana would be the central
character – an actress-cum-
courtesan who tyrannized over
men. Rejected by the official
Salon jury as immoral, *Nana*
was hung in a shop window in
the Boulevard des Capucines,
causing a near-riot.

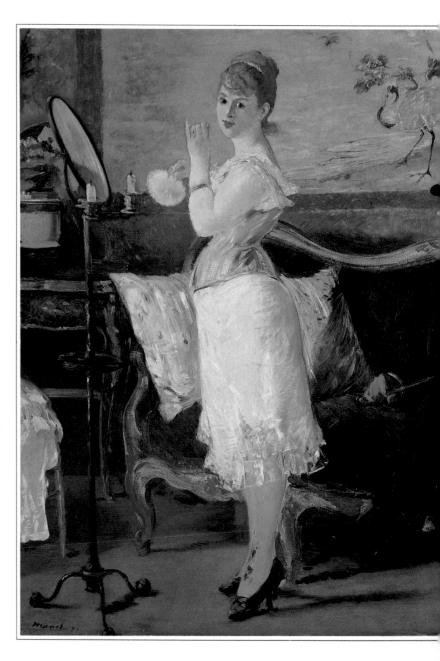

▷ **The Plum** 1877

Oil on canvas

A LOVELY STUDY in pink and mauve. The meaning of this painting has often been debated, but ultimately it hardly matters: as in other works by Manet, the picture, not the 'message', is what counts. The subject sits in a café with an unlit cigarette in her hand and a popular delicacy – a plum soaked in brandy – in front of her. She is evidently a working-class girl out for a treat; some commentators have identified her as a prostitute, or have described her as tipsy, but there is no solid proof that either is the case. *The Plum* was painted at about the same time as *Nana* (page 60) and, like that painting, can be linked with Emile Zola's novel *L'Assommoir*. So Manet's painting, with its air of melancholy, may be echoing the findings of *L'Assommoir*, in which the poor may work and save, but cannot in the long run escape the gutter.

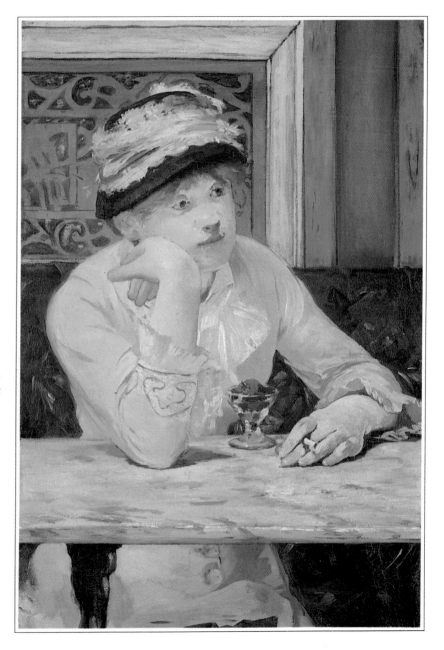

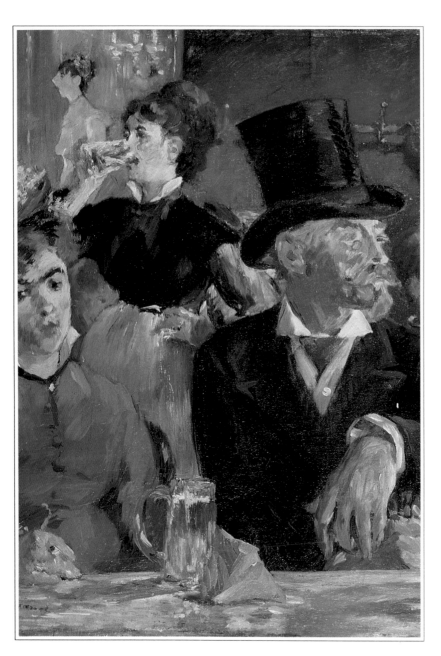

◁ **At the Café** 1877

Oil on canvas

THIS IS ONE OF a number of café scenes painted by Manet in 1878-9. Strictly speaking, it is a café-concert, where the customer paid an entrance fee to come in and watch or listen to dancers and singers; drinks could be ordered, but there was no obligation to buy. Unlike his friend Degas, Manet was more interested in the audience than the performers, although he did paint *Singer at a Café-Concert* at about this time, showing an elegantly dressed female performer in the open air. Here, neither of the principal figures seems interested in the singer, or in each other, perhaps because they come from widely different classes. The setting was a specific place on the Boulevard Rochechouart called the Cabaret Reichshoffen. Despite the stillness of the principals, the reflecting mirrors and brilliant colours create a splendid sense of clinking glasses and bustle.

▷ **Inside the Café** 1878

Oil on canvas

MANET ORIGINALLY painted
Inside the Café as part of a
larger canvas. As so often
happened, he became
dissatisfied with his work and
cut it up, preserving two
fragments, artfully arranged so
that they could stand as
separate pictures. This one is
related to *The Café-Concert*
(page 65) or a closely similar
painting. Fitted together,
jigsaw fashion, the part of the
table on the right of this
picture and the part on the left
of *The Café-Concert* make a
plausible unit. However,
Manet must have done a good
deal of subsequent work on
Inside the Café, replacing the
stage background with
window-glass and making the
customers face inwards. As it
now stands, the picture seems
very different in mood from its
'relative': instead of the noise
and bustle of the café- concert,
it suggests the welcoming
warmth and intimacy of a café
on a chilly day.

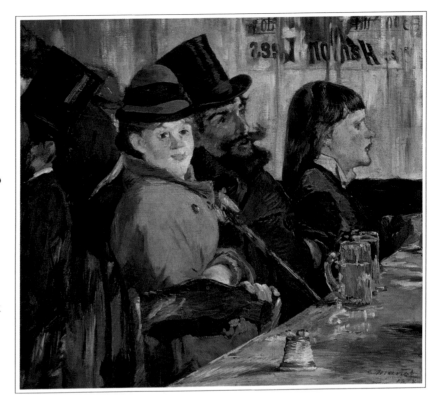

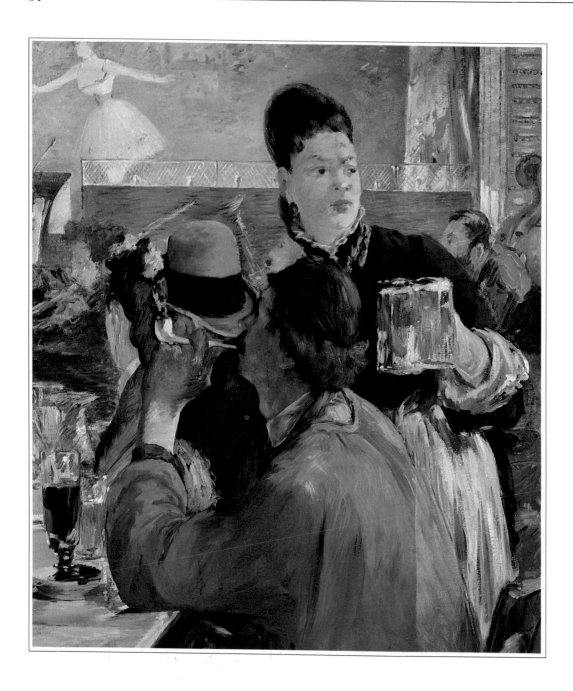

◁ The Café-Concert 1878-9

Oil on canvas

ALSO KNOWN AS *The Barmaid* or *The Beer Waitress*. By the time this was painted, the café-concert had become a Parisian institution, combining lively stage performances with bar facilities. Manet employed a real waitress as his model, and as she insisted on bringing her boyfriend along, he went into the picture too: he is the stolid figure in a workman's blouse, puffing on his clay pipe. The picture is probably a fragment of a larger painting; its relationship to *Inside the Café* (page 63) is described in the caption to that picture. But there is also a smaller, more 'close-up' version of *The Café-Concert* in the Musée d'Orsay, Paris, which some experts regard as the original. The Musée d'Orsay picture is more like a portrait of the waitress, who is not too busy to look amiably across the tables at the spectator; in this one she is working hard, serving one order while noting the existence of the next one.

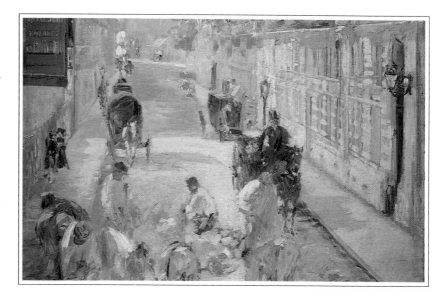

△ The Road Menders in the Rue de Berne 1878

Oil on canvas

THIS VIVID STREET scene shows the view down the rue de Berne from the window of Manet's studio in the rue de St Petersbourg; it was close to the Gare St-Lazare and the scene of *The Railway*. Manet painted other versions of the same view in which the street is decked with flags to celebrate France's national day. For the work shown here he executed a number of preparatory studies, which makes the way in which the final picture was painted all the more interesting. It was done with swift lively brushwork, as if spontaneously, omitting many details; the road menders in particular have been created with a few highly visible strokes of paint which are very effective in capturing their energetic movements.

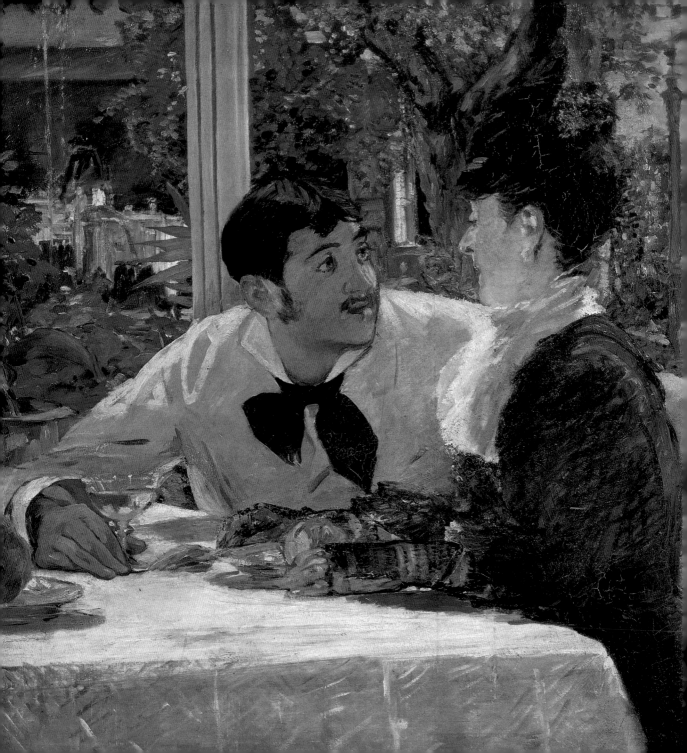

◁ **Chez Père Lathuille** 1879

Oil on canvas

ONE OF THE MOST purely pleasurable of all Manet's paintings. This might easily be a bitter-sweet scene from a French novel of the period – the older woman wooed by the penniless young man. While there is in fact no 'programme' to accompany the painting, Manet evidently intends us to read something into its details – the young man's all-too-sincere gaze, the assumed intimacy with which his arm stretches round her, the woman's tense yet not unresponsive attitude, and the neutral presence of the waiter. Yet the final choice of subject was almost accidental. Manet was impressed by the good looks of the son of Père Lathuille's proprietor, and started painting him in his dragoon's uniform with the actress Ellen Andrée. One day Andrée failed to show up, and the irritated artist substituted another woman, Mlle Judith French. But the new combination failed to please Manet, so he scraped down his canvas, made Lathuille take off his uniform and put on Manet's own jacket, and started again. The result was a masterpiece.

▷ **The Conservatory** 1879

Oil on canvas

IN THIS PAINTING, Manet's command of brilliant colour and feeling for textures is unsurpassed. Elements such as the lush, exotic plants, the blackest-black tailcoat worn by the man, the woman's pleated costume and the bars of the bench, create an eye-dazzling interplay between the natural and the artificial. Seen in this way, the Victorian stiffness of the people is not out of place, although it may not have been Manet's conscious intention: he is said to have encouraged them to move and talk, and even to have brought in Mme Manet to keep them entertained. The conservatory was part of a temporary studio in the rue d'Amsterdam that Manet rented for a few months in 1878-9; the models were Jules Guillemet and his American wife, whose impeccable appearance is explained by the fact that the couple ran an *haute couture* salon in the rue St Honoré.

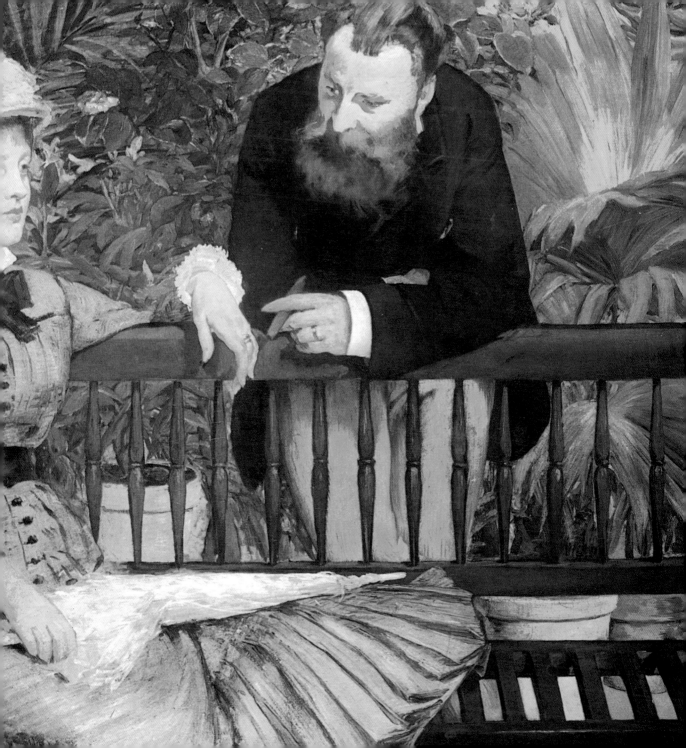

▷ **Interior of a Café** 1880-1

Oil and pastel on linen

By 1880, with the onset of
locomotor ataxia, Manet was
suffering from such severe
pains in his legs that he spent
several months at Bellevue
undergoing hydropathic
treatment. He described the
regime of baths and massage
as 'torture', but he seems to
have minded his exile from
Paris almost as much; bored in
the countryside, he mainly
confined himself to painting
still life. On his return to the
capital Manet plunged back
into social life, but his
continued weakness was
reflected by the frequency with
which he now worked in the
less physically demanding
medium of pastels rather than
painting at an easel. Manet's
pastels can be a little cloying –
they are the work of a sick
man relishing the sweetness of
youth and spring – but here
he has produced an
atmospheric masterpiece,
evoking the café life which he
had taken up again with such
pleasure.

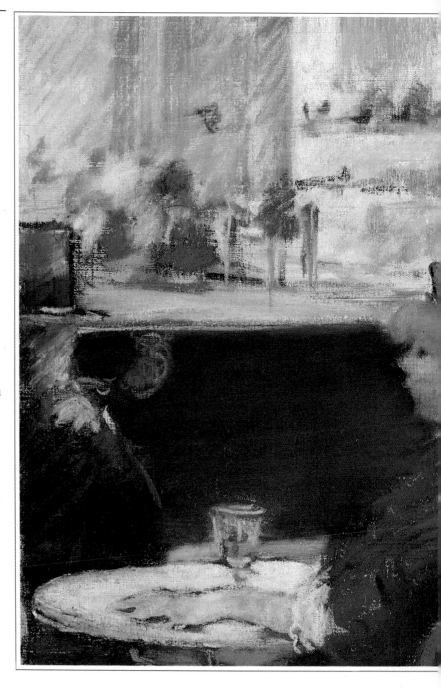

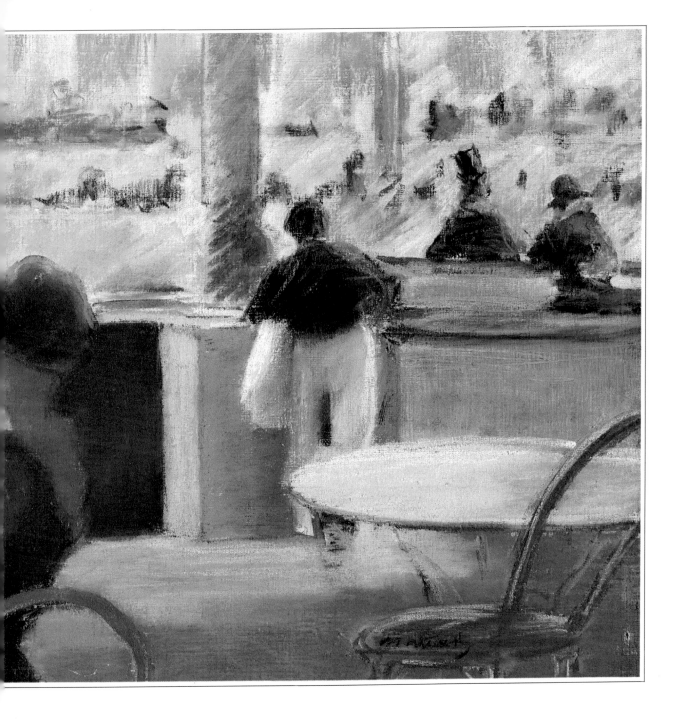

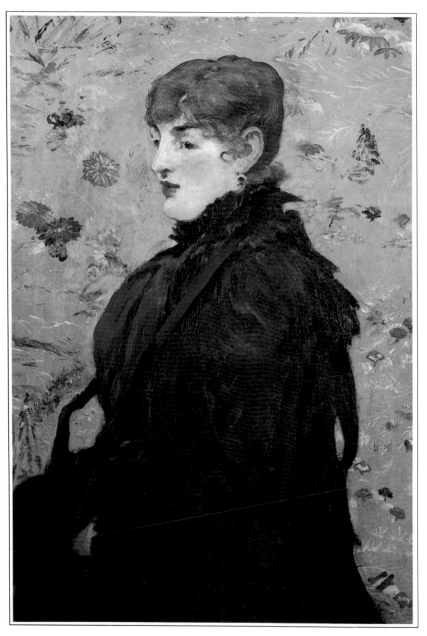

◁ **Autumn** 1881

Oil on canvas

THROUGHOUT HIS CAREER, Manet tried to adapt the tradition of the Old Masters to the distinctive tone and style of his own ('modern') age. In 1881 he revived the concept of the Four Seasons, represented by beautiful women seen against appropriate floral backgrounds. Only two of the pictures were completed. *Spring* was a portrait of a young actress named Jeanne de Marsy; fresh and pretty, if a little conventional, it was one of Manet's successful submissions to the official Salon. Against a background of chrysanthemums, autumn is represented by Méry Laurent, a woman in her early thirties who had run away from her native Nancy and enjoyed an adventurous amorous and theatrical career. Genuinely cultivated and interested in the arts, Méry Laurent became very attached to Manet: every year, after his death, she is said to have laid the first lilac of the season on his grave.

▷ **Portrait of
Henri Rochefort** 1881

Oil on canvas

THIS BRISTLING PORTRAIT
captures the fiery character of
Henri Rochefort, who was one
of the most controversial
political figures of his time.
After the fall of the Second
Empire and France's defeat in
the war of 1870-1 against
Prussia, Paris was taken over
by radicals who organized a
Commune which challenged
the new republican
government. Manet had left to
join his family and so missed
witnessing the Commune and
its bloody suppression by
government troops. Among
the captured Communards
was Henri Rochefort, an
aristocrat-turned-radical. In
1873 he was sentenced to life
imprisonment and transported
to New Caledonia, but the
following year he made a
dramatic escape. When Manet
met him, he had not long
returned to France as a result
of an amnesty. Manet made
several attempts to portray
Rochefort's escape, but finally
gave up and produced this
portrait.

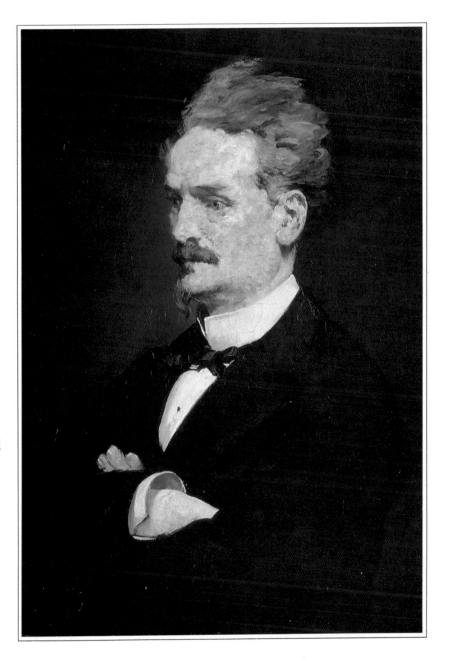

▷ **A Bar at the Folies-Bergère** 1882

Oil on canvas

THIS WAS MANET'S last big, ambitious painting, devoted like so much of his art to portraying modern Parisian life. It was probably intended as his swansong, for by this time the painter could no longer walk without the help of a stick, and could work only intermittently. Manet made sketches at the Folies, but painted the picture itself in the studio, hiring a real barmaid and setting her up behind a marble table covered with bottles, glasses and fruit. The basic conception is a brilliant one: we are faced by the barmaid, ready to serve us, while we see the audience only as reflections in the mirror behind her; the performance is invisible except for a glimpse of legs and boots on a trapeze bar in the top left-hand corner of the picture! In *A Bar at the Folies-Bergère* Manet created his final Parisian masterpiece.

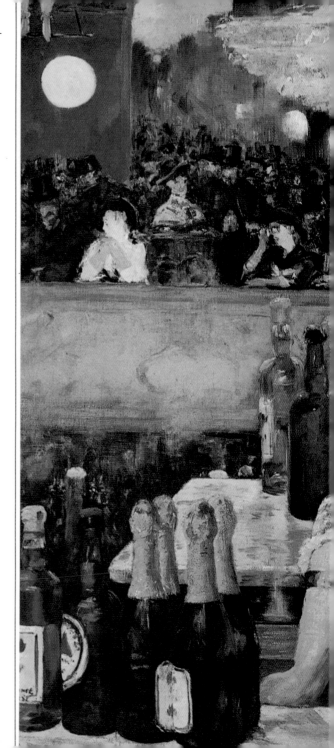

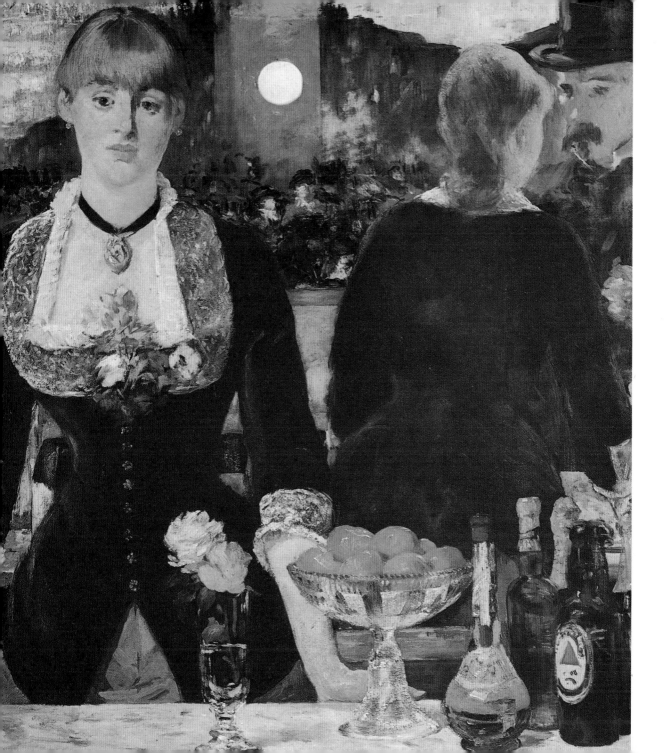

▷ The House at Rueil 1882

Oil on canvas

THE EXTRAORDINARY thing about this picture is its freshness and tranquillity. When it was painted, Manet could barely walk and was regretting his decision to rest in the country, away from the distractions of Paris. So his two views of the house, and the absence of any human figures, do not represent a change of style or outlook: there was simply nothing much else to paint, and any form of portraiture would have been difficult to do since Manet could only work for short periods. But, come what may, a painter must paint: with unconscious irony Manet declared that 'I need to work to feel well.' Here he has adopted the Impressionist technique, building up the picture with swift, separate brushstrokes to create a vivid, natural atmosphere, while the more evenly painted house gives the composition a distinctly un-Impressionist stability. The placing of the tree is an audacious but entirely successful compositional device.

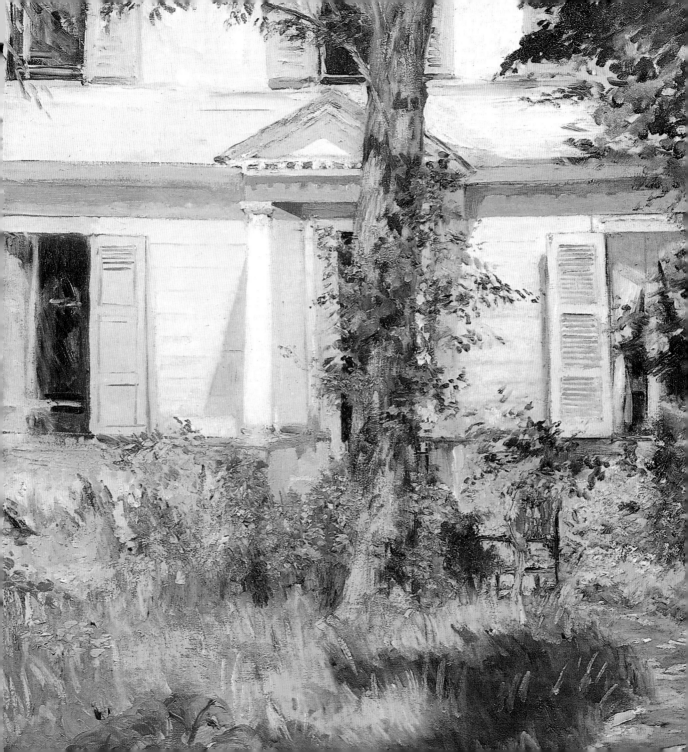

▷ **Roses and Tulips in a Dragon Vase** c.1882

Oil on canvas

DURING THE FINAL MONTHS of his life Manet was too ill to paint elaborate compositions. He occupied himself with a series of small flower pictures (this is one of the bigger ones), placing just a few blooms in a champagne glass or vase against a neutral background. The painting seems to have been done very rapidly and, despite his fatal illness, with an unerring touch that makes the flowers look astonishingly fresh and fragile, as if the slightest tremor would set the blossoms falling. Manet's love of flowers was well known, and during this period he was inundated with them from friends such as Méry Laurent. One day, when her maid arrived with more blossoms, Manet asked her to sit for him, and began a pastel portrait which was found on his easel, unfinished, after his death on 30 April 1883.

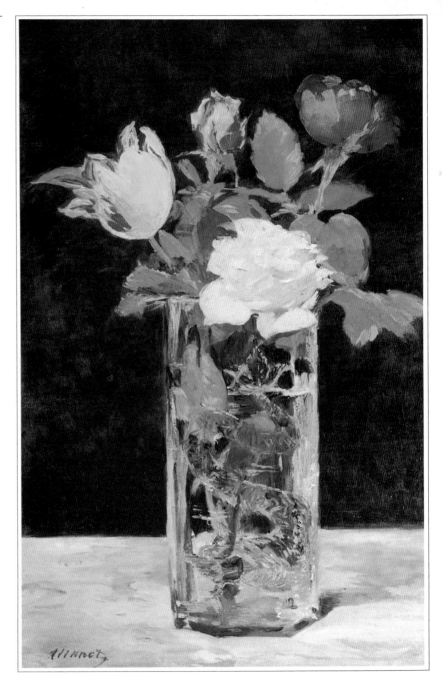

ACKNOWLEDGEMENTS

The Publisher would like to thank the following for their kind permission to reproduce the paintings in this book:

Art Institue of Chicago, Mr & Mrs Potter Palmer Collection, 1992. 424 Photograph © 1994, The Art Institute of Chicago, All Rights Reserved 18-19; **Glasgow Museums : The Burrell Collection** 70-71; **Hamburger Kunsthalle** 60; **Reproduced by courtesy of the Trustees, National Gallery, London** 64; **Musée d'Orsay, Paris © Photo R.M.N** 14-15, 32, 44-45; **National Gallery of Art, Washington DC. Collection of Mr & Mrs Paul Menon. © 1994 Board of Trustees of National Gallery of Art** 61; **Neue Pinakothese, Munich/Photo: Artothek** 30-31; **Private Collection, Switzerland** 36-37; **Walters Art Gallery, Baltimore** 62.

Bridgeman Art Library, London /Bayerische Staatsgemäldesammlungen, Munich 48; **/Ny Carlsberg Glyptotek, Copenhagen** 8; **/Cincinnati Art Museum, Ohio** 23; **/Courtauld Institute Galleries, University of London** 74-75; **/Giraudon/ Louvre, Paris** 24-25, 26; **/Kunsthalle, Hamburg** 73; **/Louvre, Paris** 12-13, 28, 40-41, 54-55; **/Metropolitan Museum of Art, New York** 46-47, 52-53; **/Musée des Beaux-Arts, Nancy** 72; **/Musée des Beaux-Arts, Tournai** 49, 66-67; **/Musée d'Orsay, Paris** 9, 22, 33, 34, 58; **/Musée du Petit Palais, Paris** 29; **/Museu de Arte São Paulo, Brazil** 57; **/National Gallery, London** 10-11, 35; **/National Gallery of Art, Washington DC** 20-21, 39, **/National Gallery of Victoria, Melbourne** 77; **/Private Collection** 16, 38, 50-51, 65; **/Provincial Security Council, San Francisco** 56; **/Sammlung Bührle, Zürich 78; /Staatliche Muséen Preussischer Kulturbesitz** 68-69; **/Staatliche Muséen Preuss, Kulturbesitz** 68-69; **/Städelsches Kunstinstitut, Frankfurt** 42-43; **/Städtische Kunsthalle, Mannheim** 27; **/Walters Art Gallery Baltimore, Maryland** 63; **/Zentrales Museum, Essen** 59.